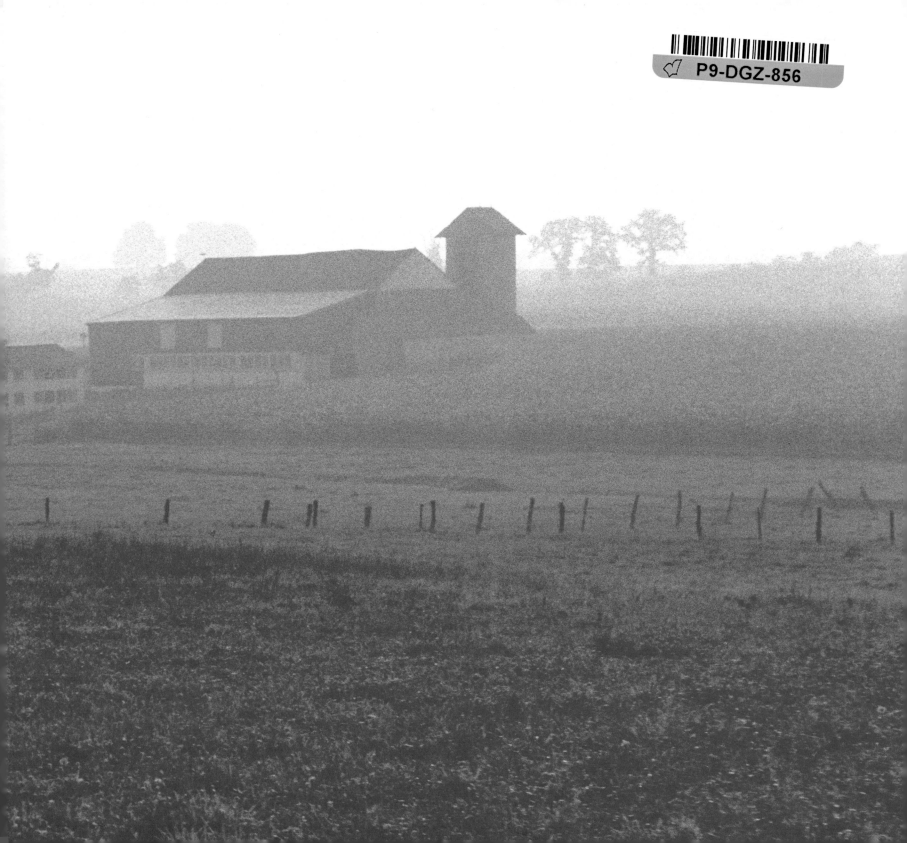

FIELDS OF PEACE

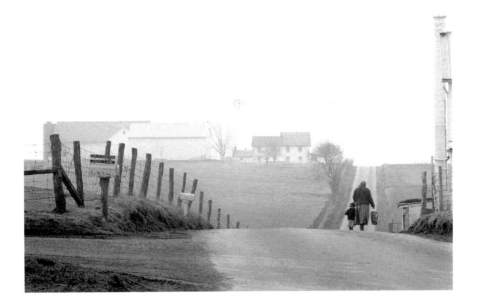

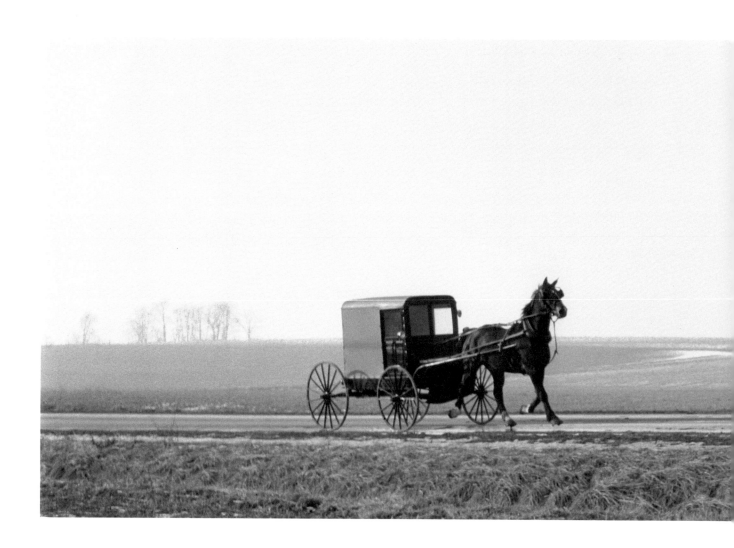

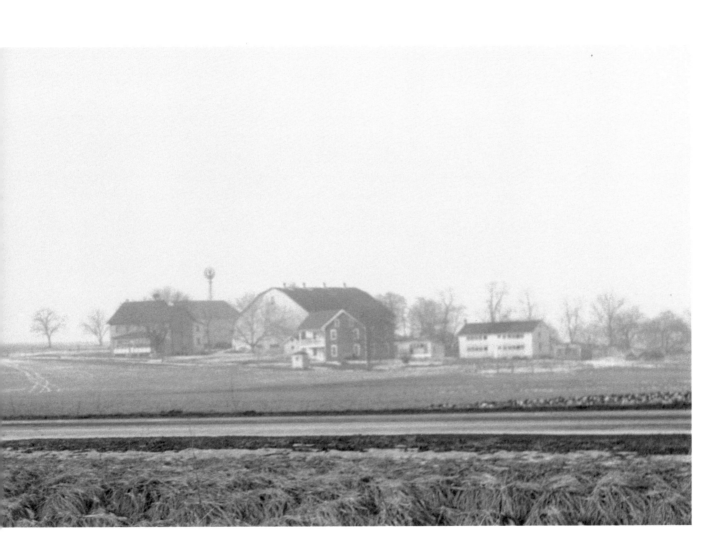

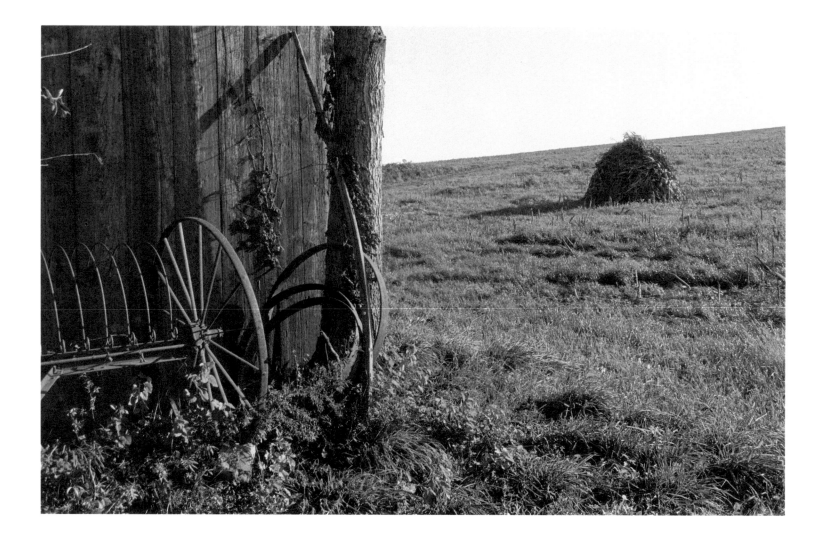

FIELDS OF PEACE

A PENNSYLVANIA GERMAN ALBUM

PHOTOGRAPHS BY

GEORGE TICE

TEXT BY MILLEN BRAND

FOREWORD BY SUE BENDER

DAVID R. GODINE · PUBLISHER

BOSTON

AN IMAGO MUNDI BOOK

Revised edition published in 1998 by
DAVID R. GODINE, *Publisher*
BOX 450
JAFFREY, NEW HAMPSHIRE 03452

BOOKS BY GEORGE TICE

FIELDS OF PEACE, *A Pennsylvania German Album* (with Millen Brand)
GOODBYE, RIVER, GOODBYE (with George Mendoza)
PATERSON
SEACOAST MAINE, *People and Places* (with Martin Dibner)
GEORGE A. TICE, *Photographs 1953-1973*
URBAN LANDSCAPES, *A New Jersey Portrait*
ARTIE VAN BLARCUM, *An Extended Portrait*
URBAN ROMANTIC, *The Photographs of George Tice*
LINCOLN
HOMETOWNS, *An American Pilgrimage*
STONE WALLS, GREY SKIES, *A Vision of Yorkshire*

DESIGNED BY EARL TIDWELL
REVISIONS BY GEORGE TICE

Library of Congress Catalog Number 73-98062
Copyright © 1970 by Millen Brand and George A. Tice
Foreword © 1998 by Sue Bender
Afterword © 1998 by George Tice
ISBN 1-56792-076-4
LIMITED EDITION ISBN 1-56792-085-3

ACKNOWLEDGMENTS
Thanks to Ken Robbins, Claudia Ansorge, Sally Arteseros, Millen Brand, Jonathan Brand,
Earl Tidwell, Marie Tremmel, Beverly McInerney, Jean Elizabeth Poli, Harvey Dwight,
David Godine, Stephen Stinehour, Scott Moyers, and Sue Bender.

Printed in the United States of America

To the memory of Richard Bruggemann,
a fine photographer and a dear friend

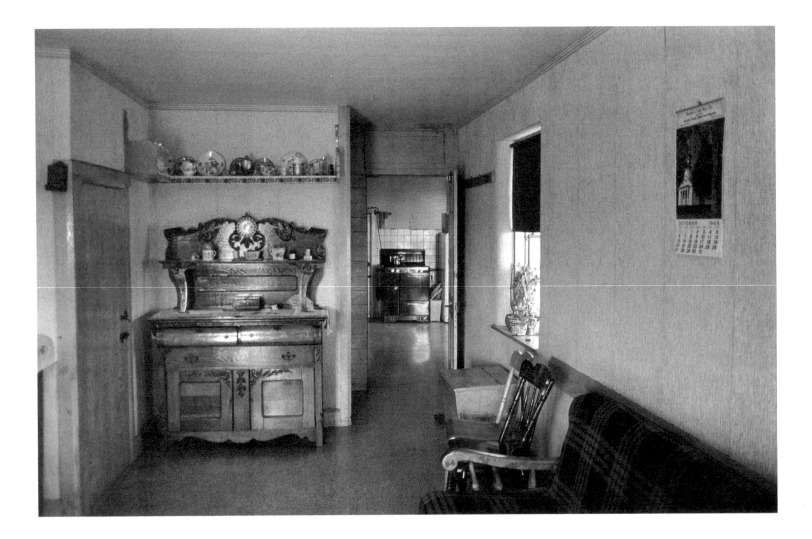

FOREWORD

How rare it is to see, really see.

George Tice has that gift. He is an artist at seeing.

Tice's photographs in *Fields of Peace,* and the words of Millen Brand that accompany them, have kept me company for a very long time. I treasure this book.

When I was asked to write a foreword for the new edition, I was honored but concerned. I am not an "expert on photography." What I know is that each time I look at one of these photographs I have a direct experience. How to put words to that experience was the challenge. I'm reminded of the expression "fresh mind." Each time I look at one of Tice's photographs I have "fresh seeing," and powerful recollections of the times I lived with the Amish.

It was on my return from a visit with the Amish that I first "met" George Tice (though we have never met in person). On the walls of a friend's house were three photographs showing the Amish and their way of life. These pictures went straight to my heart. They were calm, quiet, but they had the "thunder of silence" I had felt when I had first seen their quilts.

My friend said that George Tice, the photographer, had done a book filled with these pictures. I went out immediately to buy the book–*Fields of Peace.* It was out of print. After much searching I found a used copy.

The pictures had a heartbeat.

Spare.

Disciplined.

Evocative.

Uncluttered interiors, gleaming with the care they receive; shimmering white barns; the perfect geometry of trees in an orchard, bundles of grain, dead corn-stalks in winter. A straight horizon under clouds or a moon.

They speak of the repetition of daily tasks, generation after generation, of a life devoted to family, faith and farm.

The pictures caught the essence of their "spirit." They warmed my heart.

A group of four elders chatting, all sporting long white beards and spectacles, and wide brimmed hats, reminds me that the Amish think in terms of "we," not "I"–eating together, working together, singing together–a sense of responsibility to the family and the community. Everyone pitches in.

Pristine white farmhouses, clothing silhouetted on the wash line, two young boys, walking up a rural country lane, and on the opposite page, a young man harnessing his mules to plow the field. They use no high powered modern machinery.

I remember when I first became really aware of the rhythm of Amish life. It was three days into my first visit and I felt like I was waking up to an Alice in Wonderland reality. They used horses and buggies, had no radio or TV, and dressed as though they lived in the 19th century—the women in long dresses, hair parted in the middle and pulled severely back, the men with bushy beards that are never cut—all this was surprisingly easy to adjust to.

What was startling was the quality of time. They didn't rush. The Amish moved through their day unhurried. For me time was still a burden—there was never enough of it. The Amish had no labor saving devices, yet time felt abundant and generous. I was living in a tranquil world where a calendar, not a clock, is placed in the buggy.

Tice's honest pictures celebrate the ordinary. They are unsentimental. His palette, black and white, leaves room for the imagination. When you look closely, it's not only black and white but a wonderful, wide spectrum of muted subtle tones.

Like the life he documents—all of one piece, spare, uncluttered, and full of a boundless joy.

This is a book to be read, savored in an unhurried way—a book to come back to again and again, a book for those days when you need to be reminded of what really matters.

Fields of Peace is Millen Brand and George Tice's offering to us. They have given us a wonderful gift.

Sue Bender

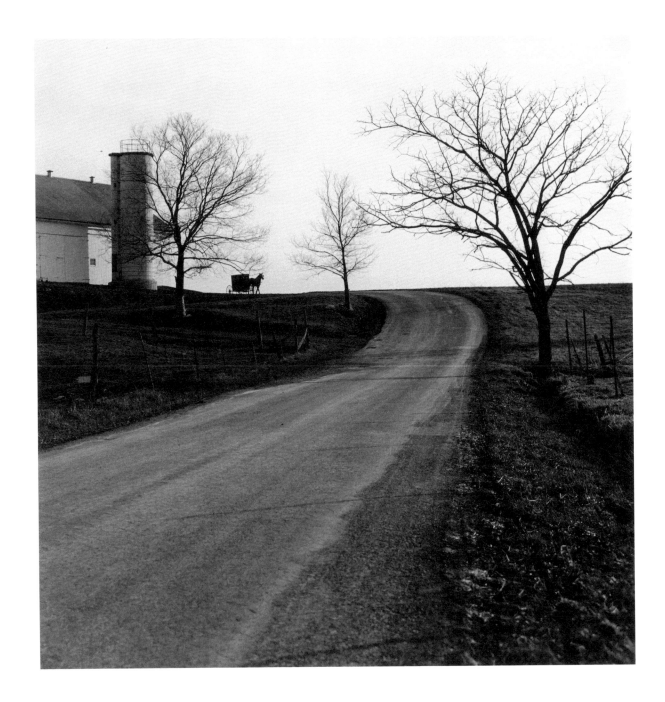

INTRODUCTION

ALBUM is a pleasant old household word for a book of family pictures. Relatives and friends like to look through such an album, and somebody in the family will usually identify the pictures or give the background as the pages turn. Such is my assignment here, a privilege because George Tice's photographs are so beautiful, but also a right because I actually am a member of a Pennsylvania German family (even if, strictly speaking, only a second cousin). My great-grandfather, a surgeon, Dr. Emmanuel Welty Myers, emigrated from Pennsylvania to northern Indiana before the Civil War, and a ninety-two-year-old woman in Wolcottville with whom I once talked told me she had known him when she was a young girl and had heard him use the *Deitsch* (the dialect), since then lost to my branch of the family. But still there I am, definitely a part of the family, and when in my thirties I moved to Berks County, Pennsylvania, to "the area," and lived there for ten years near the small town of Bally, I had the sensation of being in a haunted or haunting place, a somehow familiar place, and of resuming kinship.

So my text accompanies these pages with right. But my right and knowledge

go beyond family in the narrow sense. As soon as I was living among the Pennsylvania Germans, I had the constant wish to come nearer to them, and since I had early in my life become infected with poetry, my way of coming nearer was to write poems about them, a book of poems I've been steadily–or unsteadily–at work on for a quarter of a century: *Local Lives.* At first I wrote only about what I came across in a casual or accidental way, but then I tried presumptuously to gather in a whole representative cross-section of life, intimate daily life, and folklore and history, and found myself closer and closer to a people whom I admired and loved more the more I knew about them.

The Pennsylvania Germans to this day continue using the *Deitsch*, and that might seem to be a barrier. I admit it shook me to walk down my Crow Hill (Kroppa Berg) road and have preschool children stare at me uncomprehending when I spoke English to them. But in school they learn English and become bilingual. They then have at their command the dialect that comes relatively unbroken from eighteenth-century Palatinate, and also a remarkably fluent, strong English. It irritates me that attempts are made to represent this English as odd or transliterated dialect. It isn't. It has only a shade of tonal difference from the English of other Americans. The word "down" may have "dahn" in it, for example, or a sentence accent may be in an unusual place ("Did you go to school today?") or a phrase may be shortened ("all" for "all gone" or "it doesn't look" for "it doesn't look right"), but even this difference is becoming obsolete. There is just an interesting other cadence. So I had no difficulty in communicating with my neighbors and only felt a little out of it when they lapsed into *Deitsch* at home or in groups. I picked up some dialect myself; *cum esse*

(come eat) and *gae shlofa* (go to sleep). I felt my way into the language and was not excluded.

So little was I excluded that this happened. One day I was attending a farm-program meeting, and a slate of officers was to be elected. I found myself nominated as an alternate for the county committee, and before I knew it I was in a tie vote for this minor office. I thought: This has gone far enough, and I got to my feet and said, "I'm not a farmer, I'm a teacher." On the next ballot I was unanimously elected.

Photographer Tice, who did the luminous and extraordinarily illuminating pictures for this book, also has local credentials. Like me, he was born in New Jersey, but as a boy lived in and around Lancaster, Pennsylvania. For a while, when George was twelve, his stepfather painted barns in the East Lampeter area toward Strasburg and Paradise, in the Amish area. It was natural that when George grew up and became a professional photographer, with a determination to do his own unitary work, he thought of this Lancaster County as his subject. He had taken many pictures before I met him and went out with him to "his" area. My area around Bally is mainly Mennonite, Swenkfelder, and Catholic. Except for one foray with a horse trader to the horse auction in New Holland, I was unacquainted with Amish country. George introduced me to that flat, rolling land lit with farms, silos, and windmills, and in return I took him on a photographing expedition through my hilly Mennonite country. But the Lancaster area was a revelation to me. I discovered that the Amish had really picked the best land in the state and were utterly and simplistically devoted to it. How much this devotion is to its beauty, how much to its lime-

stone base, I don't know. But the beauty is unarguable, of a land close to the sky just because it is so open, so embracing and accessible to all the sky's splendor of light and cloud, which man can luckily do so little to change.

Going with George, I began to feel his relationship to the place too, I began to get his sensitivity. He drove and drove, watching, waiting, spying (if I can use that word), leaving himself exposed to something that might or might not eventually come. At last, he'd stop the car and get out, and even then he seemed hesitant. Children galloped (they do gallop with coltish abandon) in a schoolyard and scooped up leaves, hiding, reappearing, fleeing and returning, and eventually working out some compromise with this young man (this "Englishman") who smiled at them and slowly lifted his camera.

Each picture had this cautious approach. I never cease to wonder how out of chance or non-chance, out of knowledge, intensity, and personal style, a photograph happens. It's an art so evidently dependent on reality that only by slow experience does an outsider learn the inwardness and individuality of photography, its parallels with the other arts.

The book, this album of pictures, started with the Amish, but George was persuaded to extend it to all the Pennsylvania Germans. And while I had a considerable knowledge of my own area, I, too, enlarged my interests and awareness in the process of writing this book, to make it more inclusive. Our hope is that it will give pleasure and the closeness of insights–even perhaps certain fresh perceptions–of a land that is as American as any other, and yet with its own quality, exciting because just slightly hidden and glancing over its shoulders at the "outsiders."

Millen Brand

FIELDS OF PEACE

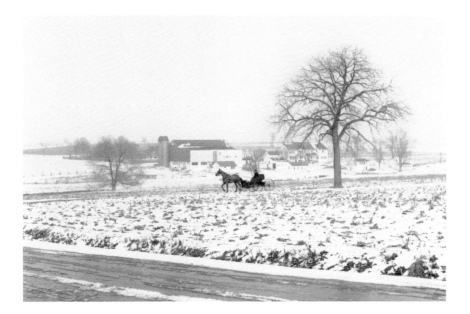

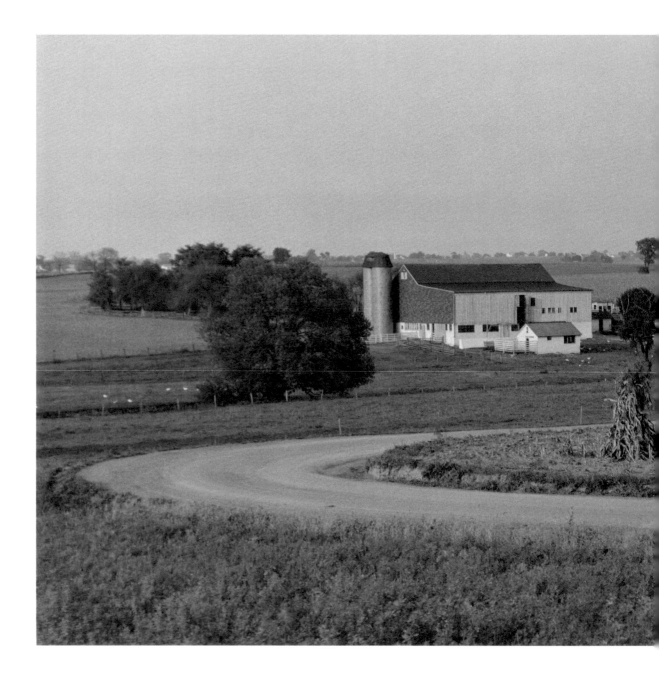

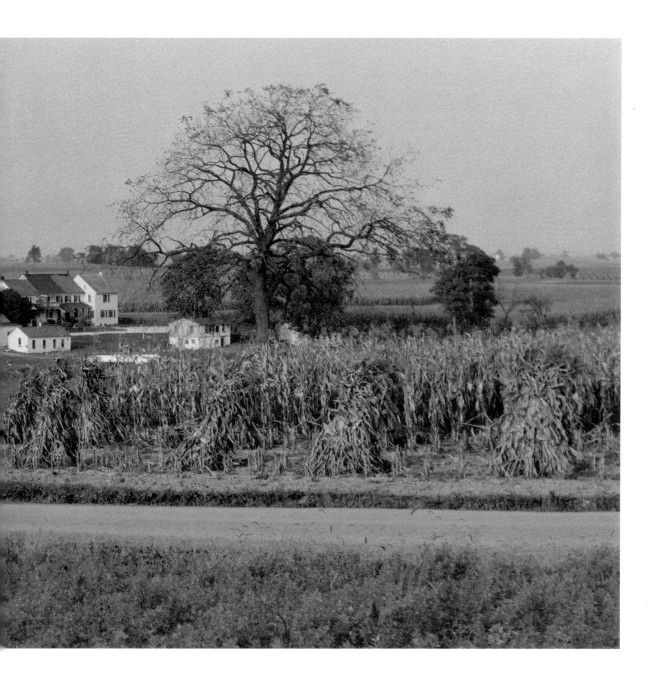

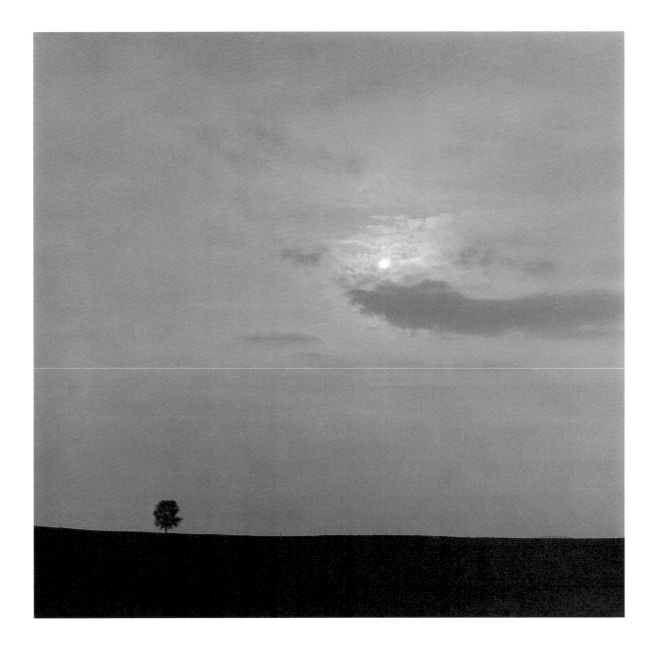

ONCE when I was driving in New Hampshire, with my Pennsylvania license plates, I inadvertently crowded a truck whose driver leaned out and yelled at me, "You dumb Dutchman." The Pennsylvania Germans are often called Dutch, which is derived from the old word *"Deutsch,"* meaning the "folk" (similarly *"Deitsch,"* the dialect). But as very few in the area are descended from Dutch—almost all are of German descent (with a miniscule graft of Huguenot)—the preference is to call them German.

For these historically "landed" people, the earth is safety and security, with a natural changelessness whose values they understand and have determined to preserve. Their life is defined by land and light. Dawn. The first moments of the day when the eye, rested, sees lines of hills or trees, or a meadow glistening with dew or frost. Or sees a stone house whose corners are straight as a plumb line—barn walls too—and dawn often with a saffron tinge that is dreamlike, like a blessing. Even in full daylight, the light is evanescent and tender. It ripples in the corn or along the waving wheat. It descends to the pastel blossoms of potato plants, or orchards

reach their pruned limbs in ritual rows climbing the warm side of hills.

Corn. The corn is like a two-sided fountain, pouring incessant light off its wide blades and with the jet of pollen spikes at the top like foaming water.

Potatoes. Crates of dug potatoes lying on a field, and a farmer at sundown going out in a flat plank wagon to haul them in, hawing the horse in the twilight. Sunset produces a light complementary to dawn but different, somehow larger and with deeper colors because the colors are darkening. A new moon in the sky cuts the clouds raked out like broken windrows of grass. Men and boys swing the crates up to the wagon, stepping in and out between the wheels, the horse stopping and starting with even plunges. As the weight grows, the horse's red haunches straighten and swell from the ground up. He snuffles the warm twilight wind, his hoofs cut the furrows.

Wheat. The "winter wheat" comes up and just shows in fall, just throwing a green gauze over the ground, and then in spring is like the first grass, ready to leap up and offer itself to the sun. When it gets tall and fluent, the wind rolls over it in waves or like a hand passed over it in a caress. And the ripe stalks bend with grain and later fill the sacks.

Such a field usually belongs to a prosperous valley farm. In the hills, land agents in the early days sold to trusting immigrants tracts of rocky ground that never made out or barely survived. Abandoned lanes today lead to houses with fallen doors and empty window frames, whose overall design indicates the care with which they were originally put up. In the cellarway of one such house a few sprays of jasmine grow, blooming in the protected spot like the farewell of some forgotten farm woman.

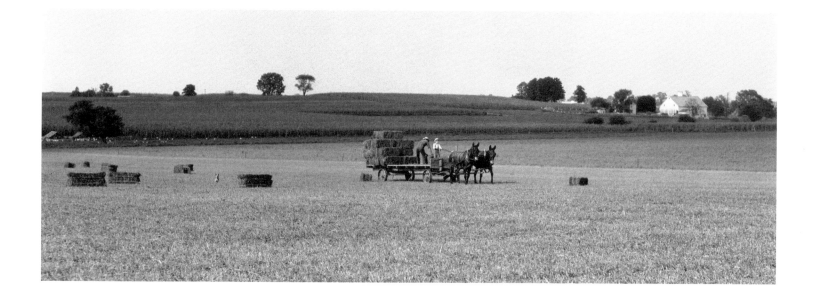

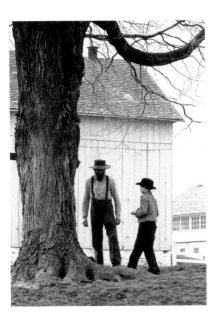

But the usual impression is of prosperity and a flourishing and steady life. Barns are larger than the houses. They may be set into a slope so that a ramp leads up to the second story in the rear. In front, they used to have a European overshoot, or *"vorschuss,"* an overhang of five or ten feet leaving a colonnaded space where the farmer could shade or shelter his horses or cattle. It can still be seen in places, giving a feeling of medieval splendor with the perfect end walls of stone holding the middle structure like some palace facade. The impression of splendor is increased when the farmer (or travelling barn painter with special skills) has put circular designs, so-called hex signs—an abstract geometry of gaudy colors—between the windows, and painted white Roman arches over windows and doors, or even white outlines of nonexistent windows and doors.

Inside the barns are the great original timbers, great lines of bare wood springing between the hay lofts. The center space rises to the rooftree with small openings for pigeon or dovecotes letting in shafts of light glittering with dust, or the light comes through easy slits in the side boarding. The horse stalls that remain have nibbled rims of feed troughs and remnants of harness. The ammonia smell of horse urine, which used to seem so tonic and clean, has generally faded away outside of the Amish area.

Another vanishing attraction is the dirt road that, because it was laid out for horses, could go around the field ends and follow the contours of the land. Few realize that paved roads came before the automobile. Local people would organize a company, put a good surface on a road, and charge a toll for it. It paid in the old days not to drag through the mud. The survivor of those old roads is the tollhouse: if today you see a house close to the junction of two roads, it is likely once to have

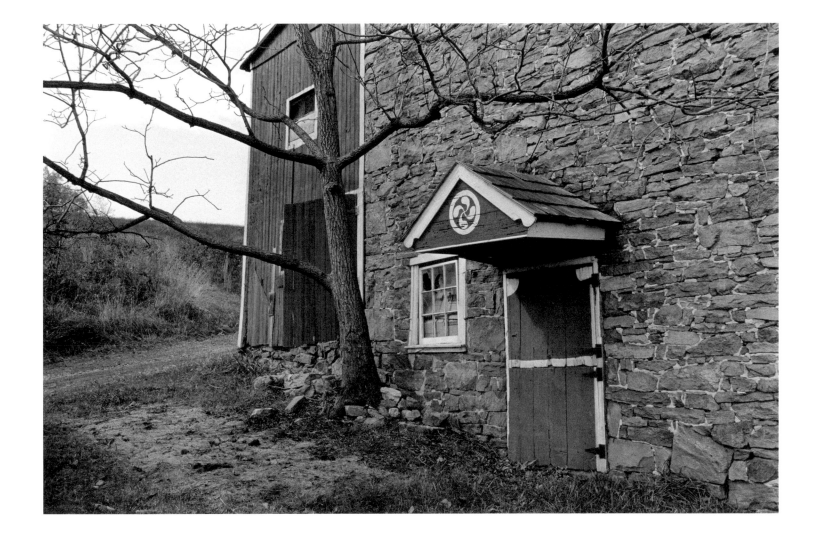

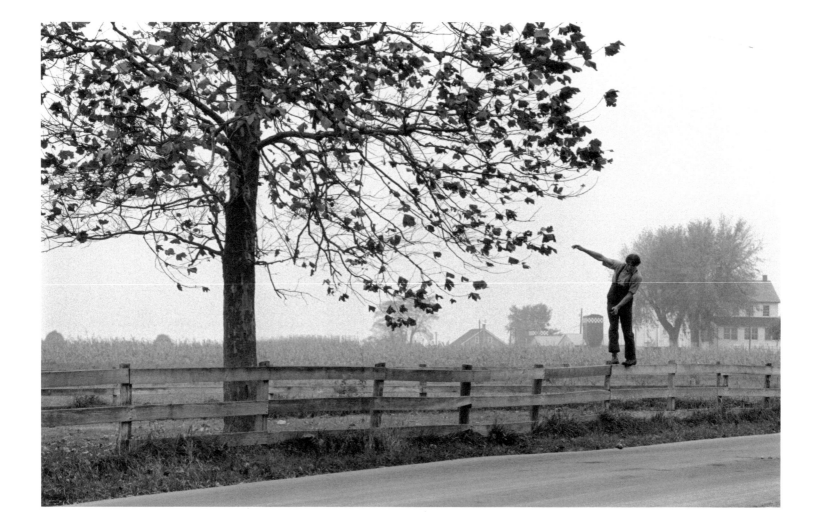

been a tollhouse where the bar was lowered until the penny or two was paid.

In Berks Hills are some of the old meandering, unhurried roads—back of Hill Church there are still even dirt or gravel roads—but more and more highways are crossing the fields, imposing their straight logic on the old natural contours. What used to be the main road is often now little more than a lane for bypassed farms. At least they have privacy and quiet. In Lancaster County change is more resisted, and the roads, though paved, tend to have the old curves, and on their blacktops one sees the anachronism of horse droppings.

A road may go under a row of trees, originally planted to protect against the sun or to provide a windbreak or just for the love of trees and shadow. Then it may come out on a rise or slope from which the great country view opens, the textured fields, fences, pastures broken by a stream where occasional wild duck may linger or a kingfisher may sit watchfully on a wire or tree branch—floods of swallows or chimney swifts skimming the low ground or circling the sky. But the overall, overriding impression is of order: fields, clean white or red buildings (or bursts of unlimited and uninhibited color—purples, yellows, blacks, blues on porch pillars and cornices, but all carefully painted), sheds, barnyards, barnyard walls with rigid coping, even flower beds whose canna lilies, phlox, and zinnias are arranged in geometric designs.

Here and there a trace of wildness, tiredness, and languor, but still the suggestion of precedent orderliness.

The scene changes with the year. Spring has the thrust of first green, crocuses and hyacinths edging up around the houses and even at lane sides (the *wild* hyacinths, and daffodils pouring down ravines. Women will be cleaning and scrub-

bing. So thorough is the urge for cleanliness in the area that you may even see a woman scouring the stains of fallen maple seeds off a well cover. Maple seeds fly through the air like small helicopters. Willows wave their delicate wands beside streams, and the streams rush with exuberant foam among wet rocks. Watercress spreads at the edge of springs.

As the summer comes on, the fields change from the various textures of red or brown earth, like fabrics, to the equally varying shades of growing corn, grain, tobacco, soy beans, hay, alfalfa. In Lancaster particularly, the tobacco plants push out their heavy velvet leaves, and boys and men appear in the fields, cultivating like guardian spirits in straw hats. The mood is serious and slow. The summer is long, the days are long. A dog barks over the strangely silent growth of an awesome fertility. Crows advance and retreat and fade through the trees.

With fall, all changes again. Now it's a rush. The harvest must be brought in while the weather allows. Pumpkins lie at the edge of cornfields, and the corn dries into gray stalks and stubble. The husks of shagbark hickory nuts fly open on the branches. The first frost whitens grass and boughs. Leaves paint the woods with sudden color, yellow maple, red ivy, and sumac threatening the understory, towers of dying leaves flaming and falling everywhere.

Again the earth becomes bare. Dust rises and settles. Birds gather to fly south. Sacks of grain lie on barn floors. The alternate boards of the tobacco drying sheds are pulled out, a pattern of shadow as the redolent ripe leaves hang downward in the inner gloom.

With winter, all becomes a sepia color cut by occasional bands of spruce or pine. Jewelweed crumbles with the yarrow, and sumac shakes its ruddy horns. Children

go muffled along the freezing roads. The snow falls, and everything merges into universal white.

And the light! Throughout the year light is ceaselessly changing from the tawny dawn touched with mists and scarves of clouds under hills, to midday and its small shadows, to afternoon and the great red rush of sunset. Such delicacy and shading! How the hills graduate into softer hues, line behind line! The definitions of light on the white side of a building, almost burning with its luminous shafts and squares. The radiance of light on a face amplifying the intensity of its response. Light appears at the end of a covered bridge seen from the inside darkness. The day itself darkens, chimney swifts narrowing one by one into chimneys, cattle lowing, and the first stars appearing. *Gae shlofa*. The mother speech becomes gentler in silence and tiredness.

Lights go out early.

It is time to sleep.

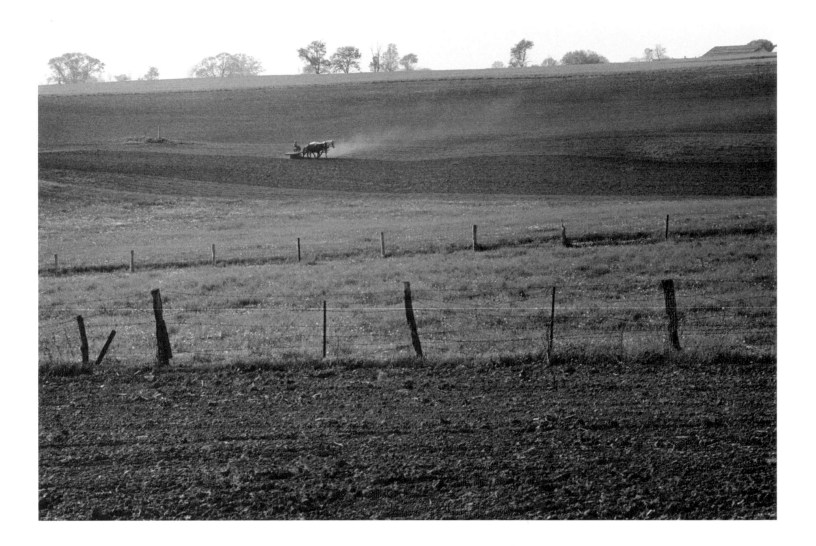

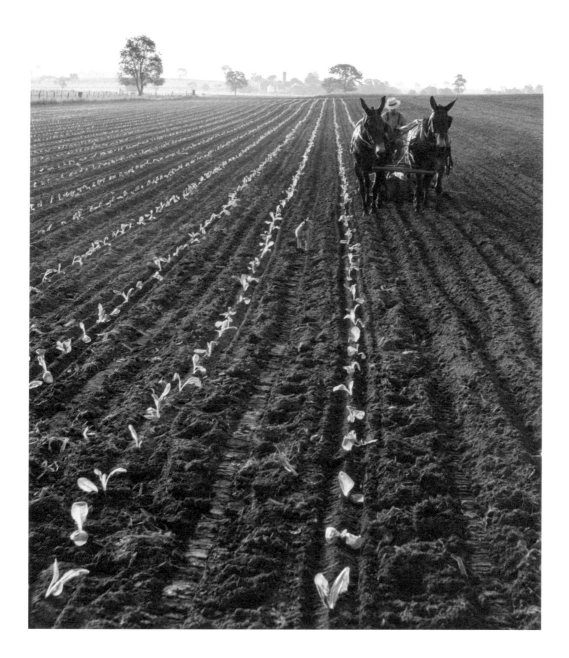

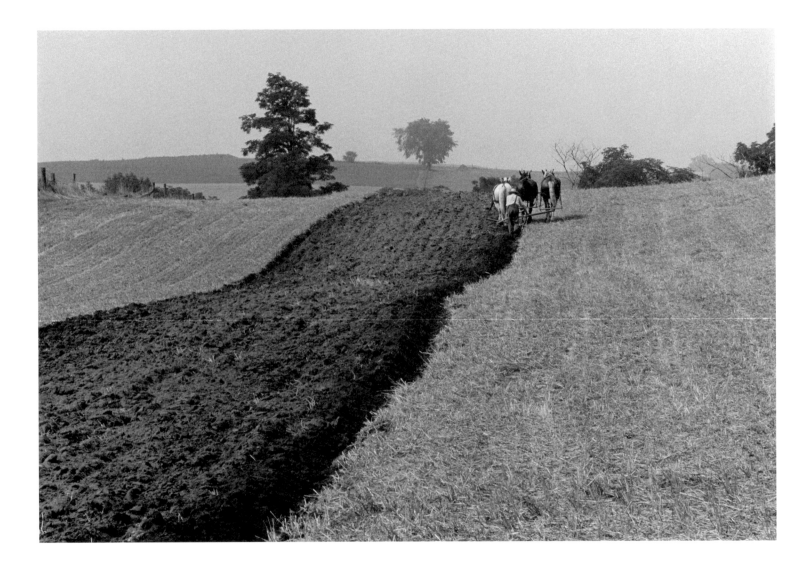

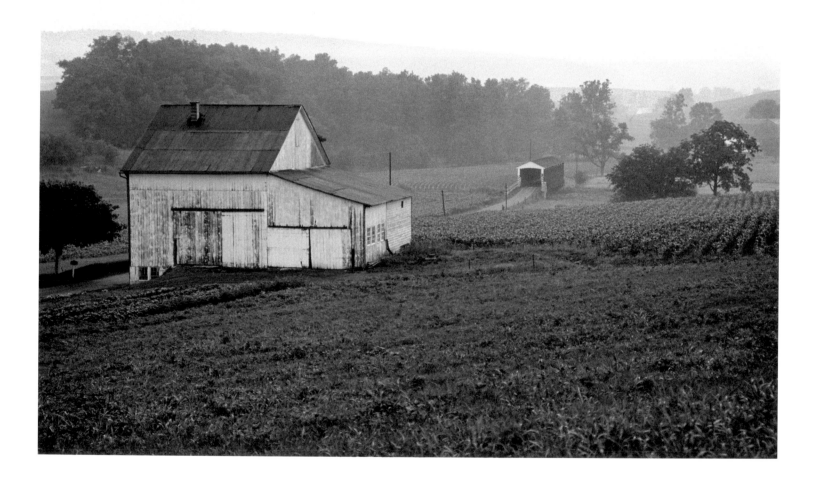

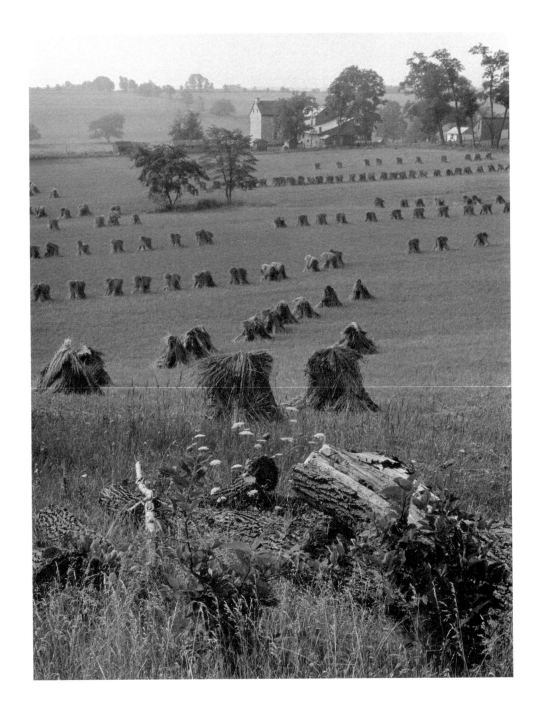

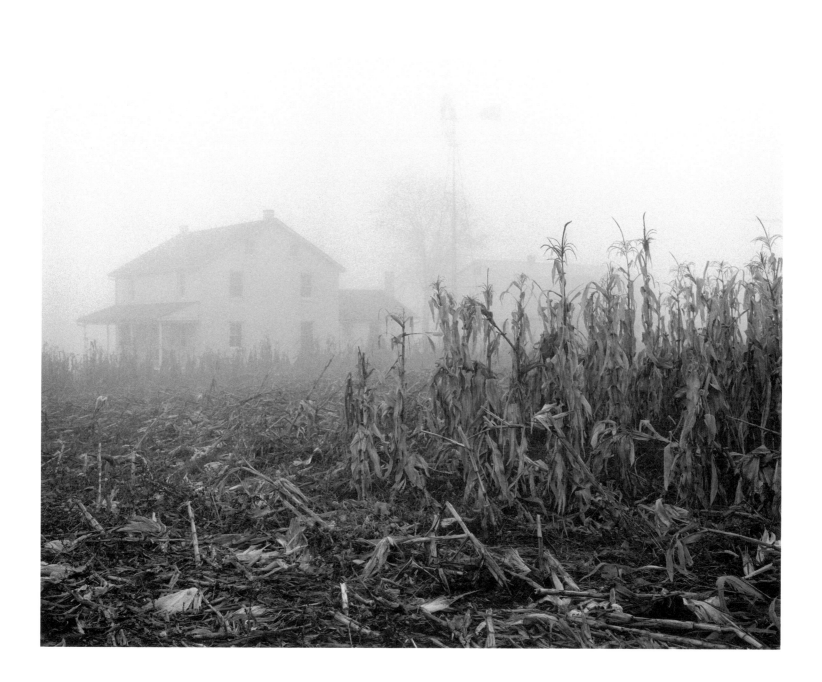

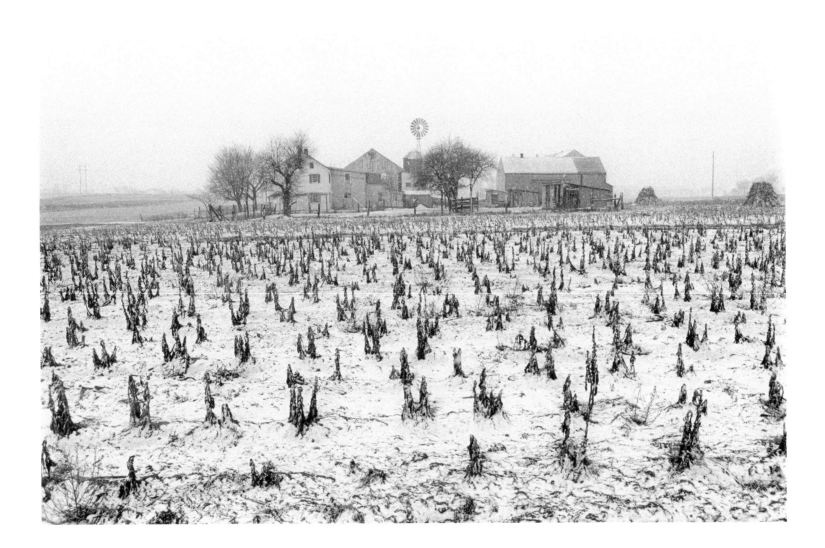

Two forces sent German peasants and farmers flooding to this country: an unbearable and seemingly unending experience of war, and religious persecution. Neither of these is simple. Neither is a very pleasant evidence of the human condition except as humans under stress often come up with hints of hope and decency, and of eventual understanding.

The Palatinate was the Rhine Pfalz area, the great valley of the upper Rhine. When European nations warred with one another–from Roman times on down– this valley was a magnetic target, its open ground a "natural battlefield." In the historic passion of the peasants and common people, it might have seemed that the Thirty Years' War was a culmination, but it turned out to have been merely a prelude.

In the winter of 1688, Louis XIV's son the dauphin invaded the Palatinate (for various persuasive political reasons) and captured Heidelberg, Mannheim, Philippsburg, Mayence, Frankenthal, Speyer, Greves, Worms, and Oppenheim. In mid-winter he and his generals ordered all the inhabitants of these towns and villages around them to get out. People hurried into the fields. The soldiery put everything to the torch.

Some of the previous wars had been religious wars (strange term) and had resulted in establishing Protestant churches in Germany, but these in turn were state churches and upheld their authority by force. They had little sympathy for offshoots of the Reformation, Anabaptist and plain-sect extremists, as they were considered, who took an unswerving position against certain church doctrines and against the union of church and state. And against all violence.

In 1898, a Pennsylvania German author, William Beidelman, reviewing the

history of the Palatinate, wrote: "The crimes committed in the Palatinate, in consequence of religious intolerance, fanaticism, and political persecution, are unparalleled in the history of human savagery. They make the blackest pages in the history of the whole world."

In many plain-sect farmhouses today, carefully placed beside the Bible is likely to be a huge book called *The Bloody Theater or Martyrs Mirror,* "compiled by Thieleman J. van Braght," which was originally published in Holland in the middle of the seventeenth century. It is a book of nearly 1200 double-column pages and consists of two parts. The first tells the story of martyrdom for the faith from the time of Christ, the first martyr, to the year 1500, and the second tells, at twice the length, the story of the martyrdom from 1500 to 1660, roughly the period of the Reformation.

The second part of *The Martyrs Mirror* is particularly human, because it is largely in the words of the participants themselves, genuine individuals, inchoate but intensely alive. Here's a sample of the tone:

"The first time that I spoke with the priests, which according to my recollection was about eight days before Whitsuntide, there came the Dean, that great, large priest, with another priest, whom we are all wont to call the Inquisitor (my master knows him well), and who cries and storms the most."

The story went on like that.

The Anabaptists from the beginning were against infant baptism, thinking logically that baptism should be a sign of faith, and faith must mean a relatively mature decision, as with the disciples of Christ himself. This belief, counter to the established churches' teachings, produced unparalleled frenzies of persecution.

The Anabaptists offered no defense, preferring to accept Christ's tenet of non-resistance as they were tortured and slaughtered. Echoes of the southern civil rights movement sound in their stories; brethren and sisters arrested and "separated" but "joyfully" singing together from their cells. A prosecutor cries that one of the brethren is a "proud fool." The brother says, "I rejoice that I am thus despised for Christ's sake."

The Martyrs Mirror is filled with woodcuts of burnings, stonings, tortures, live burials, drownings, and beheadings.

While all this was going on, something unheard-of was occurring in the "New World." A Quaker religionist, William Penn, who held a land grant that gave him a free hand, was setting up an American province on principles of civil and religious liberty (no state church), a phenomenon so remarkable in that time before the era of modern revolutions that it is breathtaking.

In this place of freedom, furthermore, fertile virgin land was being offered for ten cents an acre (this was the original price–values rapidly went up). Penn's mother was *Plat Deutsch,* and Penn had traveled in the German principalities, and he deliberately circulated invitations to "Pennsylvania" there. The first German settlers wrote back enthusiastic letters. The floodgates opened that drained the Palatinate and washed out on the "New Elysium" generations of men and women aching simply for peace. For a rest from war, from military and religious cruelties.

Philadelphia was founded, laid out on a careful design of streets and harbor. From there the settlers fanned out into the inland counties via Germantown. The counties most thickly populated by German immigrants were Berks, Lebanon, Lehigh, and Northampton.

In the first thirty years of Penn's colony, the German immigrants were almost all plain sect or sects sympathetic to the plain sects—dissidents who yearned back to early Christianity and strict acceptance of Christ's teachings. They were plain in the sense of cherishing a continuing simplicity of dress, life, and custom. They admired the Quakers and generally supported them in their policies.

The two predominant plain-sect groups were (and are) the Amish and the Mennonites. Both descended from the Anabaptists with their strong belief in non-infant baptism. They also believed the body and blood of Christ were not present in the sacrament, and had other differences of doctrine that made them highly subversive to the established churches of their time.

The Amish started with a division among the Swiss Anabaptists. Their first leader, Jacob Ammann, insisted that *"Meidung"* or shunning as a punishment for certain sins should not just be a spiritual thing, but should be practical, and insisted that man and wife shouldn't eat together, for example, if one or the other had sinned and not made peace with the church. The Amish became a more rigid and inward-turning sect, the most intransigent and unchanging—because the strictest—of all the sects.

Yet even among the Amish there are divisions and modifications. The Old Order stays almost unchanging. The Beachy Amish make concessions and, like the Mennonites, tend to offer some adaptations to changing times.

The Mennonites take their name from a "hedge preacher" and religious rebel of the early sixteenth century, Menno Simons, who led "the church in the heart" with utter devotion and courage. This branch of the Anabaptists followed many of the beliefs and practices of the Amish, of the Anabaptists generally, but with less

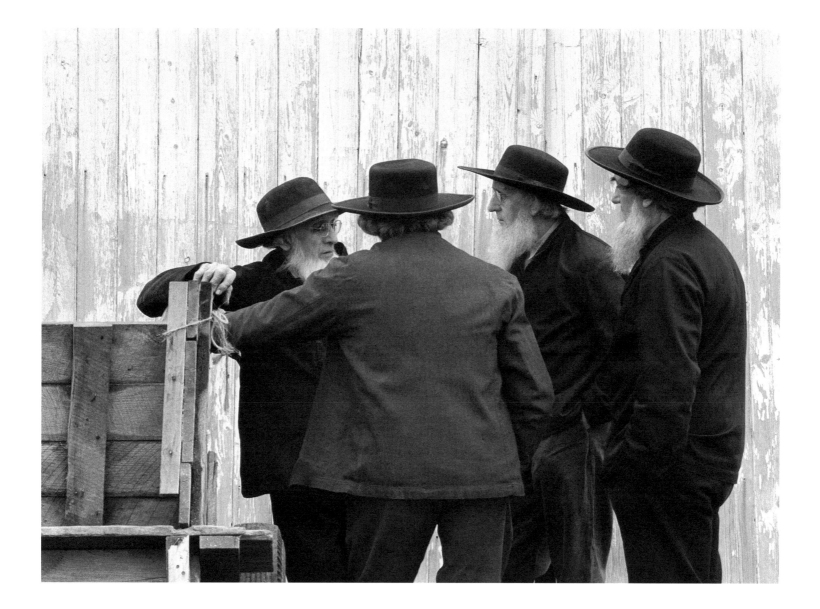

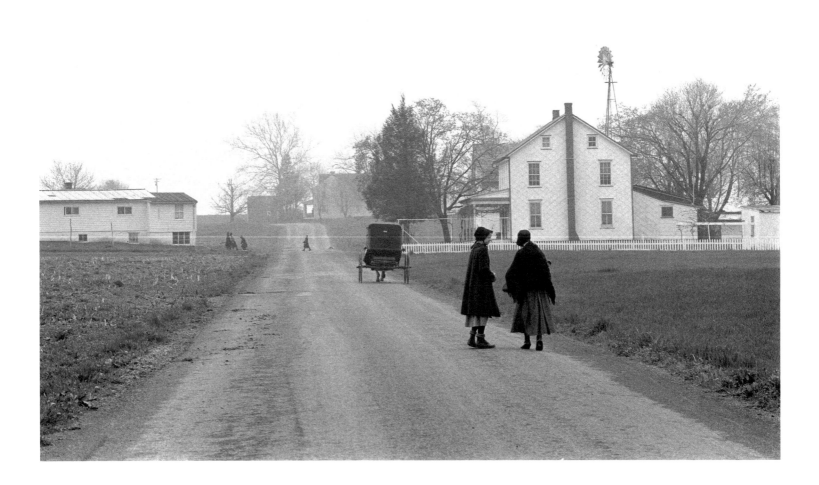

coercion and with more openness to change, more outgoingness, more willingness to relate, in service and in love, with the outsider.

The present-day Reformed Mennonites (not the Herrites) are not too much different, to the casual observer, from an ordinary Protestant church.

Much like the Mennonites in belief, but with a practice of baptism by immersion, are the Church of the Brethren, dubbed Dunkards.

The Schwenkfelders are a small group, today not much over two thousand in membership, but outstanding in their devotion to spiritual liberty and independent conscience. They are not strictly speaking a plain sect. They began with the teaching of a highly literate Silesian knight of the sixteenth century, Caspar Schwenckfeld and have been literate ever since, each member acting as if the eye of God was continually on him, so that every act was important and worth recording, a trait endearing to the historian. They added a slash of transcendent color to the area pattern, though their sympathies were with simplicity of life.

The Moravians, *Unitas Fratrum*, derive from a Protestant denomination of the fifteenth-century (tutored by the Waldensians) that spread over Bohemia and Moravia, hence the name. Nonviolent, with traits of Pietism, they went underground, almost disappearing, then re-emerged in the early eighteenth century and were welcomed by Count von Zinzendorf on his estate at Bertheldorf, across the Bohemian border in Saxony, to which they fled. Later, a group of them emigrated to Pennsylvania. The Moravians, too, tended toward simplicity of life and sympathy with the plain sects. At times they comforted and rescued the Schwenkfelders.

Pietism has its part in the history of the area and has given it a special tone. Pietism was a religious ascetic rebellion against the excesses of the upper classes in Germany and France around the end of the seventeenth century. It started without much organization, but organized or not, any attempt to worship outside the established church (in most German principalities then) was labeled "Separatist" and brought persecution. The Pietist impulse led to the Cloister at Ephrata.

Catholics had difficulty coming over. Most of the immigration was on English ships, and the English imposed restrictions on Catholic movement. Even so, some Catholics reached Pennsylvania, and a Jesuit father, Theodore Schneider, set up a notable Catholic mission in the neighborhood of what is now Bally.

In the heavy immigration that began in 1740, members of the plain sects or plain-sect sympathizers fell to a minority and high church or what might be called ordinary Protestant denominations came over in large numbers. These had a strong Calvinist leaning, including the German Reformed Church, which started under the influence of Holland (so the terms "classis" and "classes") but became German. Its first Communion service in America was held on October 25, 1725, at Falkner Swamp, and this is considered its birthday. The Reformed merged eventually with the Evangelical Synod, the two churches becoming the Evangelical and Reformed Church, and this in turn joined forces with the Congregational Christians in the United Church of Christ.

The Lutherans came as early as 1693 to Germantown, but after the mid-1800s they grew to a powerful thirty thousand in eastern Pennsylvania. They were conservative, and their principal tenet, salvation only through faith, was not sympathetic to plain-sect feeling. Martin Luther willingly admitted he slightly altered

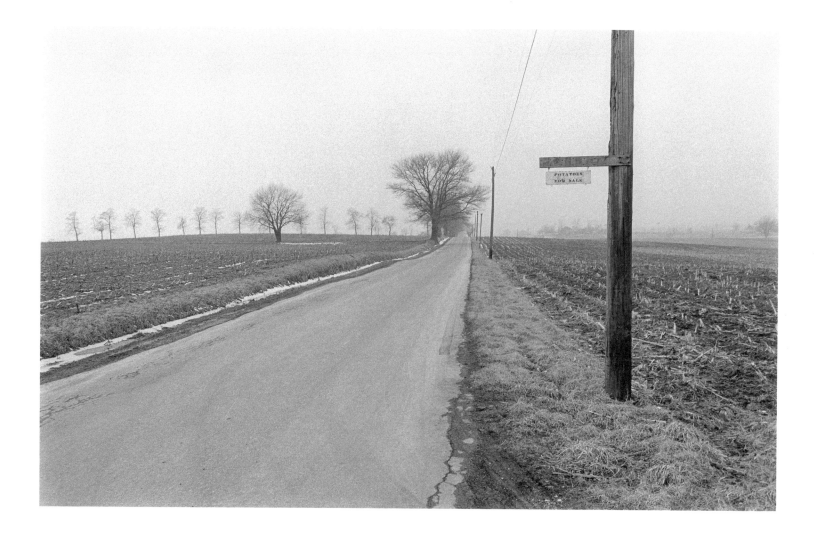

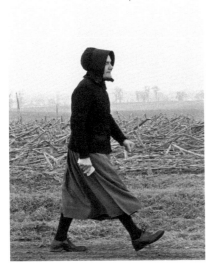

the text of the Bible when he added the famous *"allein"* ("A man is justified by faith alone") to Romans 3:28. Lutherans became a part of the German immigration that merged more easily with general Pennsylvania and American life.

The Evangelical United Brethren go back to Jacob Albright and are a predominantly Methodist group, but one that merges old lines of Pietism and Old Mennonite influence. So there is overlapping, splitting, reuniting–a wide range of belief. Wide as it is, the plain sects give the area its lasting definition.

Here then, as the eighteenth century advanced, was this extraordinary block of German or dialect-speaking people in the middle of the English colonies. Their differences among themselves were not divisive. A curious harmony established itself–Mennonites, for example, helped Theodore Schneider put up his first church in Bally, and the Jesuit mission there donated land for the site of the first Mennonite church.

The problems lay in relating to those around them, first the English-speaking colonists and then the Indians. As the German population count rose to over a hundred thousand and as they started to vote and make themselves felt, Benjamin Franklin expressed doubts about them: "[They] are allowed good in courts, where the German business so increases that there is continued need of interpreters, and I suppose in a few years, they will also be necessary in Assembly, to tell one half of our legislators what the other half says." Some Philadelphia streets had signs "only in German," which did nothing to ease Franklin's feelings.

But unity against England was soon to dissipate this distrust.

Actually it was the relations of the German colonists with the Indians that was a primary and heart-searching problem for them. Early German immigrants, like the Quakers, had just suffered from narrow intolerance and were trying to create a

new and better earth. They were prepared by nature and conviction to be friends with the Indians. Indians were the hosts, the original inhabitants, and Penn's own approach to them had been friendship. Further, Indians had been evolving for countless generations with an admirable grace adapted to their so-called "savage" environment. Historians fail to be interested in what this grace meant or what it could contribute. Little is said about the possibility that Indians and whites may not have been so far apart and might have become a single society. Many whites tried to bring this about. Particularly in Pennsylvania.

Indians were federating to abolish war, on their own and quite aside from the influence of Christian religionists. They had a growing peacefulness among themselves (and even their earlier warring had been limited). Like the white religionists, they reverenced a single Great Spirit, and each Indian had a Manitto, a personal guardian spirit that was like the Moravians' and Quakers' "inward light." They reached out eagerly to whites (some whites). They were intensely moved by Christianity as the Bible presented it. Some Moravians lived with the Indians and married them. There is more than a hint of Indian ancestry among many of the Pennsylvania Germans, and they refer to it among themselves.

If there had been only Quakers and plain sects, it might have been different, but other colonials felt superior to the Indians and cheated and robbed them and fought them in their own style. When fighting became bloody in Pennsylvania, in the 1750s, a bounty of one hundred and thirty Spanish milled dollars was offered for every scalp of a male Indian over ten years of age, and fifty for every scalp of a female Indian. The larger bounty would pay for sixty gallons of rum, and many scalps were brought in and massacres of Indians became common.

Up to the American Revolution, the relation of settlers to Indians was the

touchstone of the convictions of the plain sect and nonviolent, and these convictions often stood the test. The Revolution was a still more difficult test. German immigrants had always hated oppression–religious, royal, or fiscal–and now this anachronism of Europe threatened to be reimposed.

The Pennsylvania Germans as a whole supplied both soldiers and officers to Washington's army, and it was in part fear of their long rifles that made the British get out of Boston. Many plain-sect people kept to their pacifist principles, but offered food and medical help. In the battle of Brandywine, there were heavy Revolutionary casualties. Wounded soldiers were first cared for in Philadelphia, but when the city was attacked by the British, the wounded were taken to Lancaster County and more than five hundred were tended by the Sisters of Saron at Ephrata.

The Hessians were a special thing–a complication. Many felt sympathy for these mercenaries, men who came from the same stock as themselves and whom they differentiated from the officers. Large numbers of the not-too-hard-fighting Hessians were captured, and the logical place to keep them seemed to be among the Pennsylvania Germans. A contingent was assigned to Reading. They were "hutted" in stone huts they themselves built on long terraces on and under Hill Road, where my friends J. Lee Bausher and his wife Mildred Jordan now live. Of the thousand or so housed and loosely imprisoned there, the larger part did not return to Germany, and some may have been part of the Hessian force that went over to the Revolutionary side and formed anti-British "squadrons." Washington had suggested making "these auxiliaries our friends."

Pennsylvania Germans fought not only in the Revolution but for the North in the Civil War. The first protest against Negro slavery on the North American con-

tinent had been issued in Germantown six years after its settlement, and there was consistent and strong feeling against human slavery, a feeling celebrated by Whittier:

> "The German-born pilgrims, who first dared to brave
> The scorn of the proud in the cause of the slave . . ."

Fighting lapses away, and in "the area" it was always moderated by medical and other services and by an undercurrent of fervent prayer that men may consider "the terrible destruction of warfare and seek a better way." The fighting that was done was at times deeply motivated by devotion to liberty and was thought through as a balance between good and bad in a way characteristic of the people. When I myself moved into the area, I was struck by the open spirit of love there, a natural, unself-conscious loving-kindness apparent everywhere, governing a community where no "government" was needed.

Josephus Gerhard, a ninety-five-year-old retired farmer, blind with age but straight and clear-voiced, once told me: "I was at the barber's, and they were talking about communities. I said in ours we loved one another. One said that could not be said of any community anywhere. I said, 'Well, ours is that way.'"

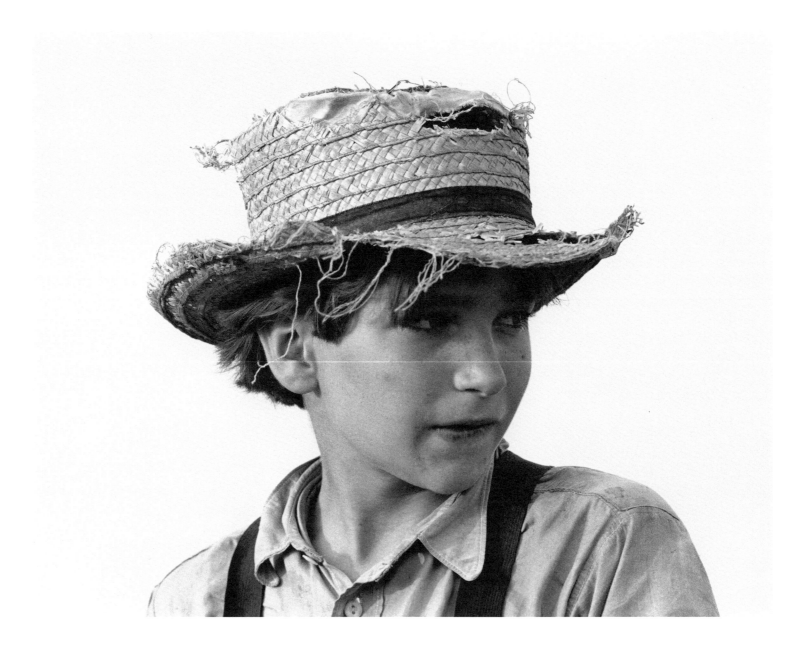

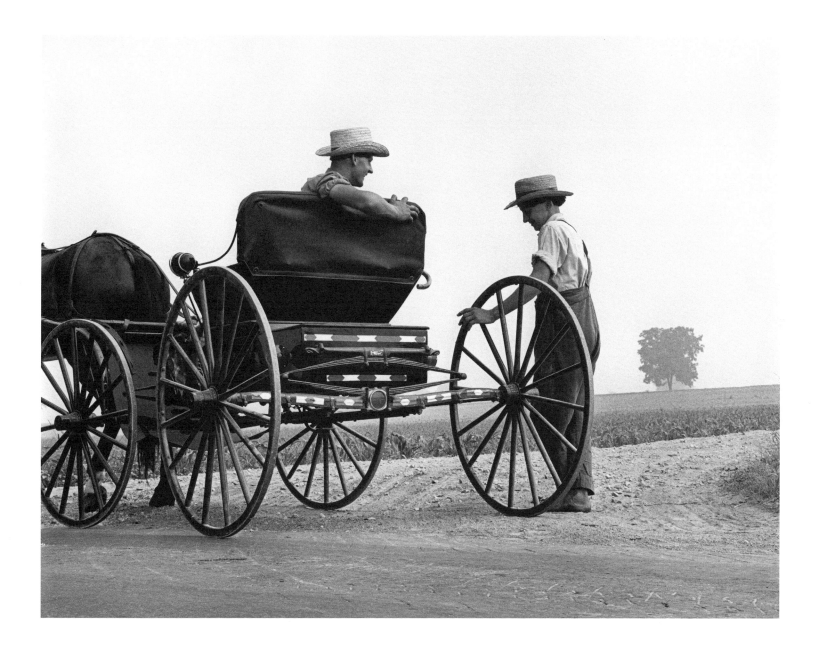

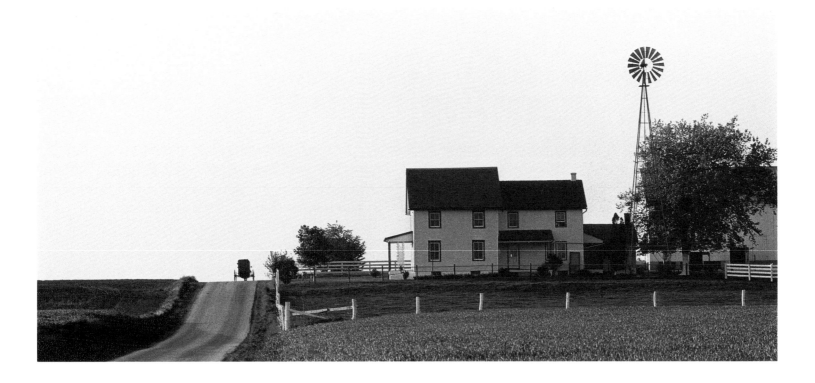

IN addition to the original counties populated by the German immigrants in colonial times, Lancaster, Bucks, Montgomery, Chester, Carbon, York, Dauphin, Snyder, and Schuylkill also had populations of Germans, and today a scattering of them spread out as far as Northumberland and Mifflin. Because they live together they have kept a homogeneity of language and custom, of course with significant variations.

Much of their life goes back to its beginnings. They came sometimes with worldly possessions, or remnants of them, sometimes not. Some brought axes, grubbing hoes, rasps, augers, seeds–most of the tools needed to clear and plant land. Some even brought iron stoves, which they disassembled to carry on shipboard and put together in some first log cabin. Some came with only the strength of their arms, the "redemptioners," and gave themselves into varying periods of bondage to pay for their passage.

Some lived in Indian caves along the Delaware. But these were people who had come to stay, and after the log cabins were built (sometimes two-story cabins), and after the palace-like barns went up, up went stone houses to proclaim the status and solidity of these people. In these stone houses Europe came west. Down Philadelphia way there might be rounded staircases taking after Christopher Wren, but here all was straight, the stone molded to a vertical perfection, with doors and windows drenched in medieval light. Windows went through walls a foot or a foot and a half thick. The outsides of these walls were handsomely fitted stone, but the insides were frugally filled in with small stone mortar of clay and straw. No cement. That came later and was frowned on as pretentious "church work."

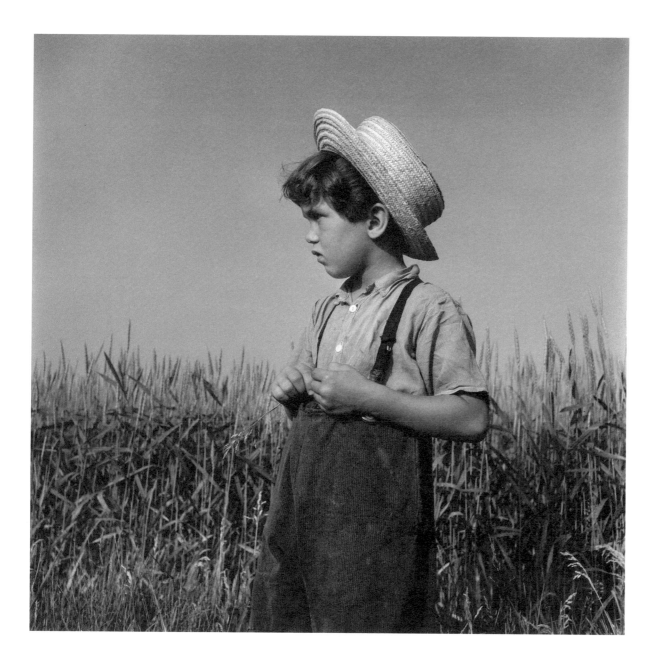

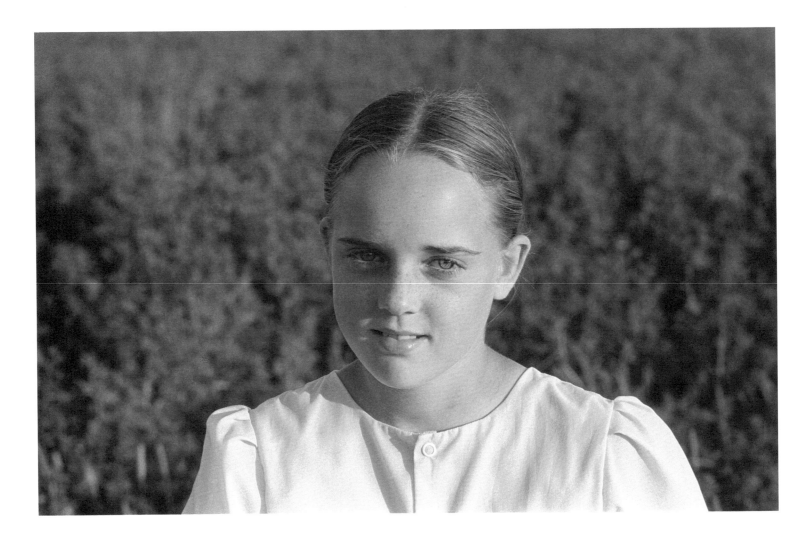

Kitchens were large, for the kitchen was often the most-used room in the house. For many years it had a wood or coal stove, and the stove was moved forward in winter and put back into a recess in summer. Now many have changed to gas or electric stoves. In the old days a dough tray let loaves of bread rise overnight, and for large families the woman ordered flour by the fifty-pound bag. "Grandpap went to Alphinus Eck and bought fifty pounds of flour, the following week he bought fifty more, the following week fifty more." Ten loaves of bread twice a week, fresh bread smelling the way no present-day bread smells, and justifying, rewarding, and fueling endless hard labor. "We butchered twice a winter. We butchered four hogs and a beef before the holidays, and four hogs and a beef after the holidays." A woman made "a furnaceful of scrapple," that local amalgam of corn or buckwheat and pork. She made sausage, liverwurst, and bludwurst and *kuddleflek* (tripe). She even made cake.

In the soft light of the kitchen, the dining table was set with china and pewter between meals, covered with gauze. Through the back door came the loot of field and garden–and milk and eggs. The cellar was filled with canned goods put up year by year.

The taste in food was plain and sensible. I was told a story of a woman who married a man who liked strawberries and who for years raised strawberries for him, indulging this extravagant taste, and at last tasted a strawberry herself and found she liked it.

I was also told about a man who "had a mouth like a bullfrog," a booming base voice, and one day his wife laid before him chicken pot pie and apple dumplings– "epple doomplings." "Halleluia!" he cried. But these stories verge on folklore.

The day-to-day truth is that the kitchen was a place of hard work, warmth, family closeness, and love.

The woman in the older days sewed. That was when almost all dresses and underwear were homemade. And when a woman had time—before or after child raising—she might knit or make lace: doilies, blue-white flowers stiffened with starch, slip-cover edges, the thinnest of transparent handkerchiefs.

From this to soapmaking. "I boiled seven kettles of soap. You put caustic soda with fat and boil it down, and after it gets solid, you cut it so in pieces."

When I lived in the area, I used to talk with older women. I wanted to know what their life had been. One thing stood out, something forgotten today—the ravages of sickness. Scarlet fever, diphtheria, pneumonia, croup—epidemics swept through the area and killed many children, and parents mourned, and often they, too, fell sick, and families helped one another at risk of their own lives. The great fear was that everybody in one family would be sick at once, with nobody to care for them. Women not infrequently got up from a sick bed, tended the children, and went back to bed.

These were the shadows. Possibly against them the nonplain-sect people threw up a defense of beauty. The insides as well as the outsides of their houses were filled with color. The backs of chairs were decorated with leaves, flower petals, and grapes and grape tendrils, often intricate designs that brought a set of chairs into unity. Corner cupboards and other cabinets, and even window seats, were ornamented. Birth, baptismal, and marriage certificates were illumined with *fraktur* art, an art that like the plain sects goes back to the sixteenth century, and imitates a decorative type face of that time called *"Fraktur,"* which itself imitated medieval

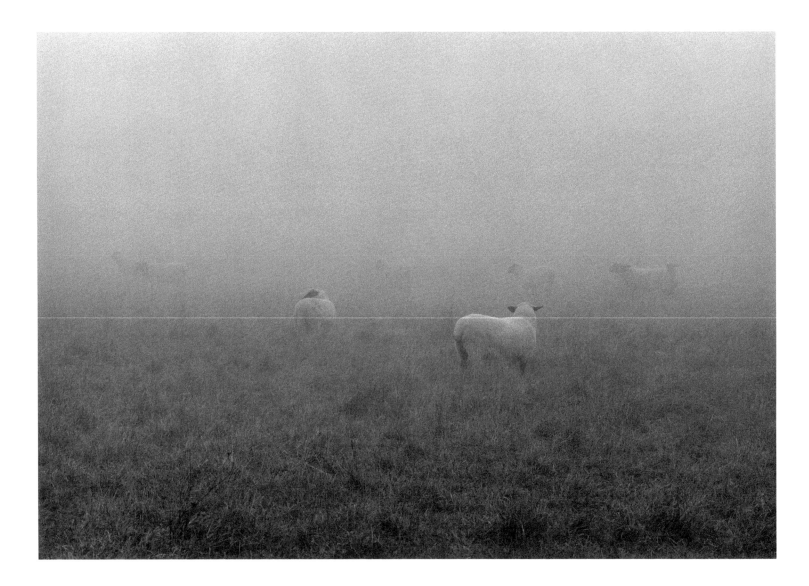

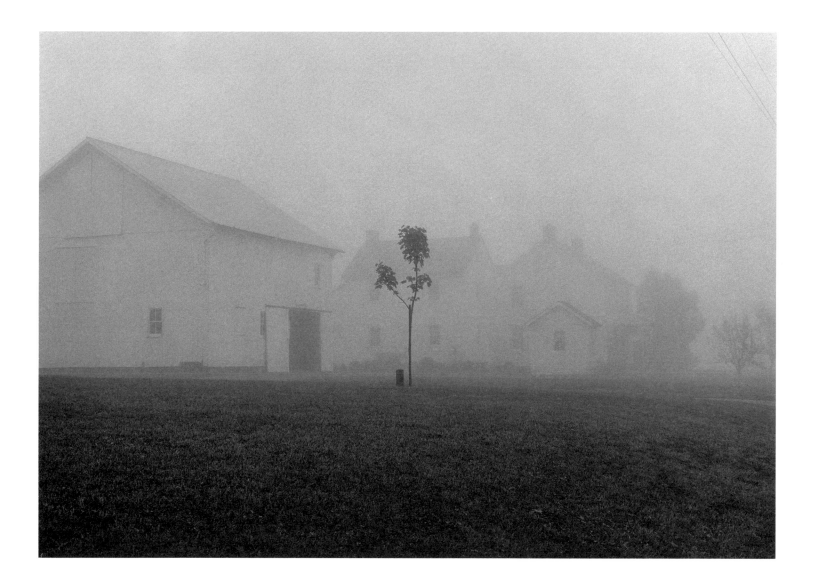

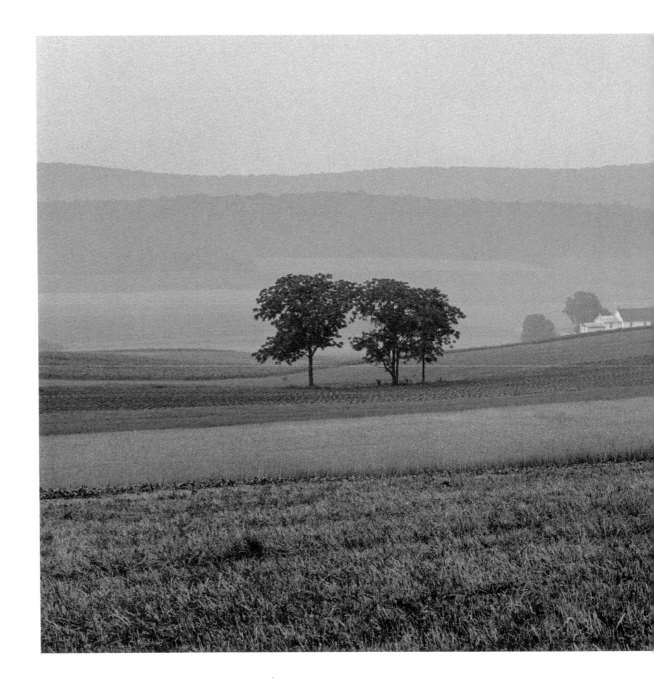

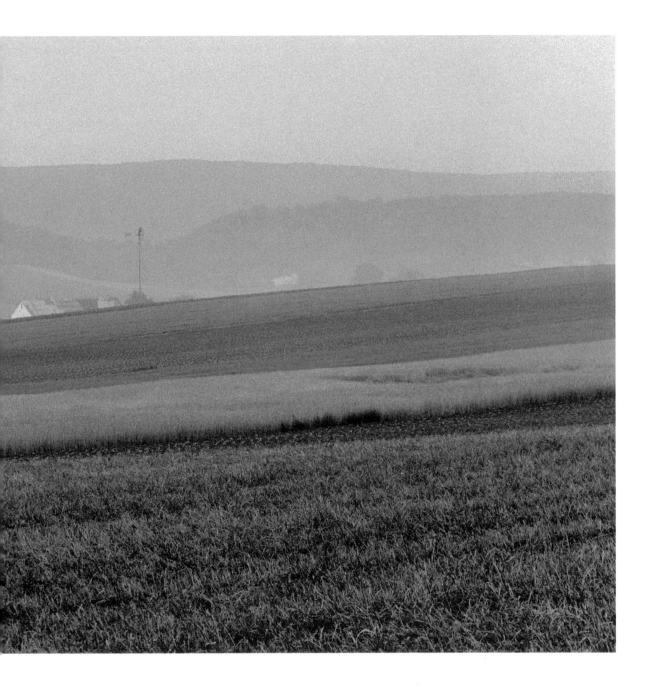

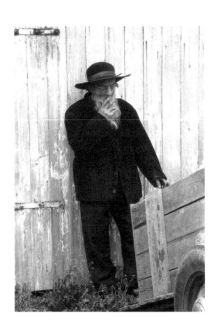

manuscript writing. In Pennsylvania, this conventional art was released to become spontaneous and individual, and some families still have fine examples of *fraktur* documents decorated with tulips, doves, and parrots, sometimes even a butterfly or a human figure.

But the culmination of this decorative art, this riot of color, was the family chest, or bride box brought over from Europe by some long-past ancestor. Chests done in Pennsylvania were often masterpieces of design, with flowers, birds, occasional horses, human figures–even flat-breasted mermaids.

These designs carry over to pottery, particularly to traditional wedding plates, which may be inscribed, in German: "To love and be loved is the greatest joy on earth."

The quilt was another art, and Pennsylvania German women had the insistent patience needed to do quilts of difficult and individual pattern, with bursts of magenta, lemon yellow, reds and greens, colors that would have intimidated women of other areas but that gave local lives a buoyant and consistent liveliness. Just as the porch posts of the houses might be purple or yellow, and eaves and porch roofs blue like the sky–or a pale blue backdrop down the back wall of the porch–so quilts were as colorful as they were warm.

Quilt making was something of an entertainment, a social function. Women traded "pieces," carefully rolled-up bits of fabric from their "piece bags," so that they could vary the coloring of a quilt they were doing. Older women, who had more time, taught the girls of a household how to backstitch and hem and prepared the future mistresses of the needle.

Useful gatherings were entertainment too, and still are: auctions, barn rais-

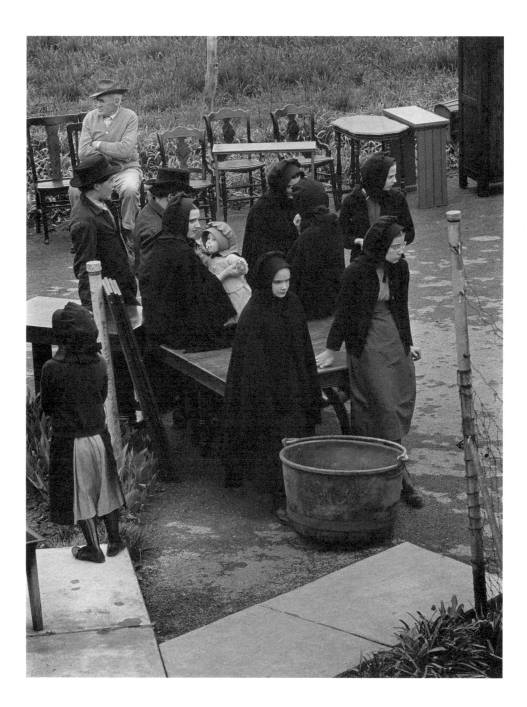

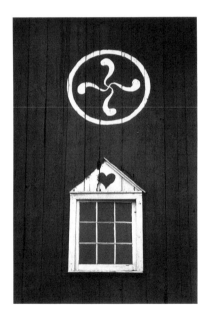

ings, farmers' markets. At a household auction, hundreds may gather for an all-day get-together and the men in certain communities may go off to a space of field or a barnyard and play *Mosch Balle,* "corner-ball." In this game, two teams of eight men apiece contend. Four men form the corners, and two men from the other team get into the square where they become targets for a fairly hard rubber ball. The ball is tossed around, gets "hot," and then is used to try to hit one of the men in the center. If the try succeeds, the man drops out of the game. If it fails, the thrower is out. This goes on till one side wins. The women watch and can get loudly involved, and a game may last hours.

Wrestling, racing, and other athletic games are popular, and some of the non-plain-sect communities may play American baseball on small fields outside of town.

Amish are not against parlor games, and some of the men become excellent chess players and take on "gay" (non-Amish) champions. Children play their own games, hand-clapping games being popular, and they are allowed homemade toys.

I mentioned porch posts and color on the houses. The use of color most typical of the Pennsylvania German is on his barn: circles with geometrical designs, often six-lobed, and it is a question whether these are hex signs (from the German word for "witch"). I have been told that the outlines of nonexistent windows painted on barns were for witches to fly into and break their necks.

Certainly few farmers would admit that these "decorations" were "really" against witches. Sensitive to this charge, one farmer (a friend told me) asked a painter to "close" the designs on his barn—paint them over with red paint—but the children pleaded with him to save the signs and he finally did.

Undoubtedly, there is superstition in the area. There is some strangeness or estrangement to all life; it is a continuity in every people. Or perhaps it is something people react to. Germans are not so far from the woods, from dwellers of the old Cimbrian forests: Vandals, Rugii, Goths–the Alemanni, fires glowing on their horned helmets as they faced the Roman lines. Whispers of blood, delays while the moon's horns go up or down, *Segensformen,* rites over wounds (dip in the wound three twigs, each cut with one stroke), *kugelsfest.* A touch of Indian powwow. So a second level of life exists under the first, denying its order even for this people, so eminently loving and orderly.

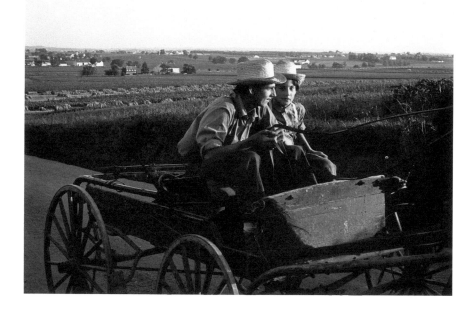

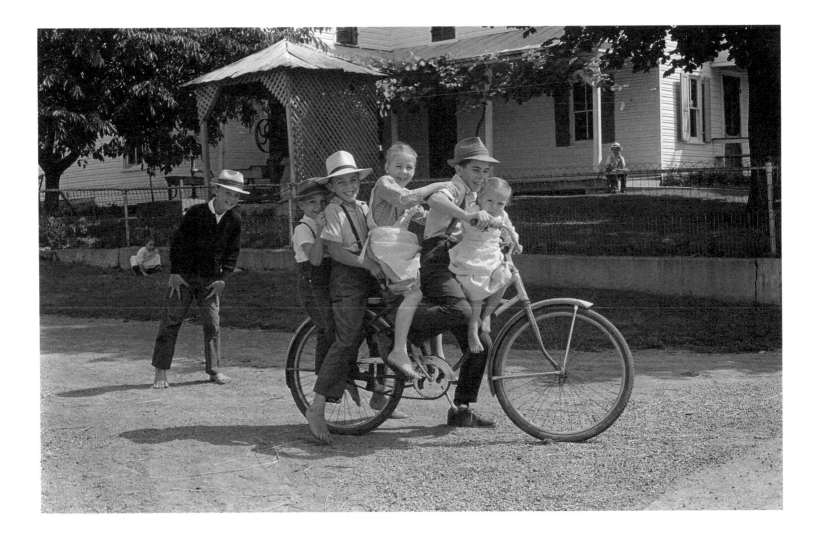

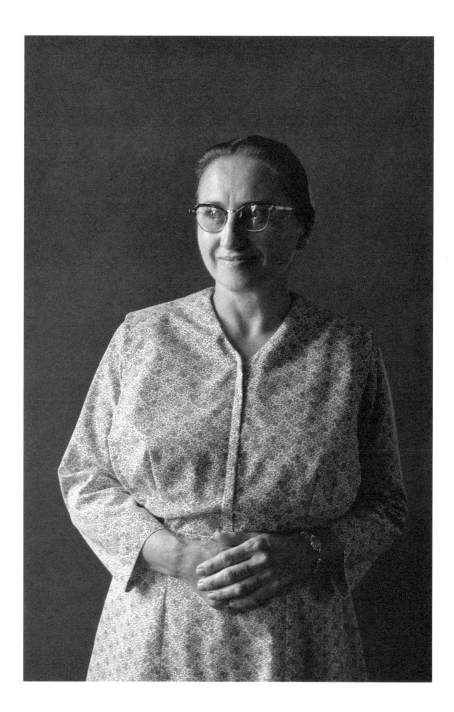

Over the plain sects, as I mentioned, lies the Anabaptist heritage of radical reform, by going away from the majority back to full acceptance of the teachings of Christ. Such acceptance is not lip service. It is living service. It affects all their life.

The plain sects do not go to war. They have as little to do with secular governments as they can. They carry this bias everywhere. I talked with a landowner whose farmer was an Old Mennonite, and the owner was afraid to get free lime from the government to spread on his fields. The Old Mennonite would object. Men should love and cherish one another directly, no government interfering or intervening. If a barn or house burns, the congregation of neighbors contributes materials and labor and rebuilds it, without insurance. It goes up in a day, dozens of hammers flashing. Love is their insurance, brotherhood their security, social or otherwise. The outer world may have economic recessions, shocks, and depressions. The sects go on, following the pattern of God and custom.

It is the Amish who particularly keep to this pattern. Custom or church ruling regulates a large part of their lives. Consider just a surface thing first. The men use no buttons on their outer clothing, and they shave their upper lips. This was originally a rejection of military officers and their mustaches and decorations—a rejection of power from which they suffered only too literally. There is moving meaning to the shaved upper lip and the hook-and-eye outer clothing.

An unmarried man is clean-shaven. When he marries, he grows a beard. Courtship follows a well-defined ritual: It's secretive. Nobody is supposed to know what is going on, but if a girl raises a lot of celery in the garden (needed for the wedding celebration), it's a sign. Only two weeks before the wedding, the couple is "published" in church after the *Schteckleimann* or go-between has made the

final arrangements. Weddings are usually in November or December (less farm work then) and on a Tuesday or Thursday. And the wedding follows a whole ritual of its own.

The Amish don't have churches in the sense of buildings (Beachy Amish excepted). They meet every other Sunday in one another's houses, and the houses are generally designed with this in mind, so that rooms can be thrown together or connected to allow a large-sized gathering. Benches, without backs, on which men, women, and children sit patiently for hours, are carried from service to service.

Everyday life is strictly ordered too. Girls and women must have long skirts (this is changing among Mennonites). Dress shoes must be plain and black only. Men's hats must be black and the dimensions of brim and crown are strictly regulated. Men's hair should be combed in a bang in front and in length be at least halfway below the ear tops. Clothing has been decided on for centuries, and its nonstyle is uniform and unifying. The boys are like small men. Small girls often wear bright dresses but always of solid colors, and they will flow across a schoolyard like a shy rainbow. Older women wear soberer dresses.

The point is that symbolic nondecorative dress, changeless from century to century, is a kind of relief. There is no need to try to outdo one another to be different. Even Sunday dress must not be showy. The children run barefoot, and if a girl's long-dress hem flashes up as she runs, no notice is taken. The faces of children are like those of angels, like visitors from an unmolested Eden or like a second soul in "normal" society. Old Mennonite children, too, have this unworldliness.

The plainness pervades their life. In the houses there are no pictures or portraits, no decorations. Perhaps a calendar on the wall. Often plants in the windows.

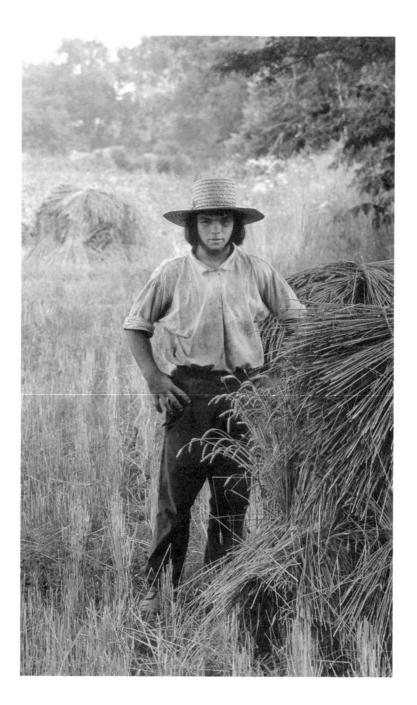

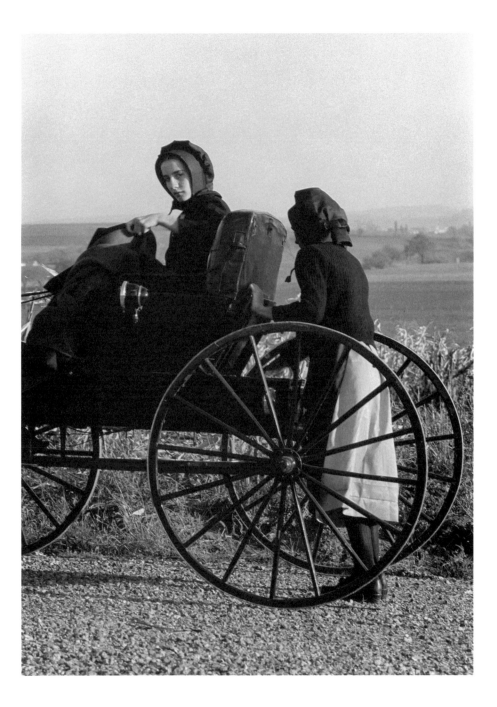

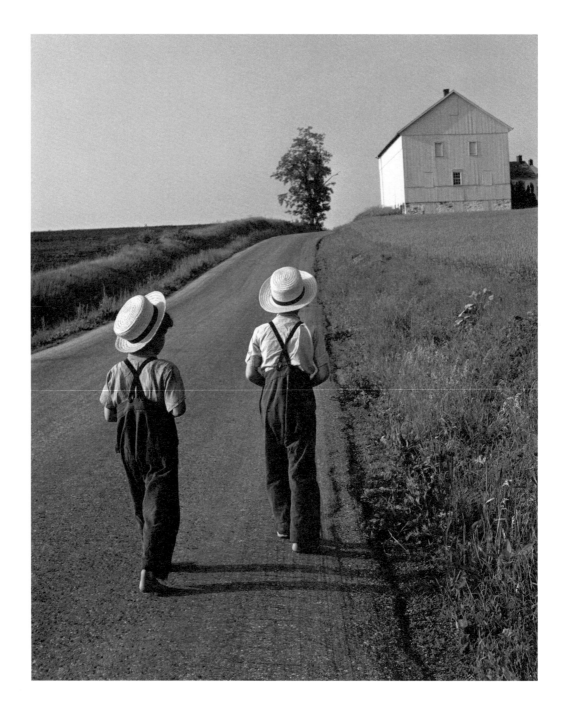

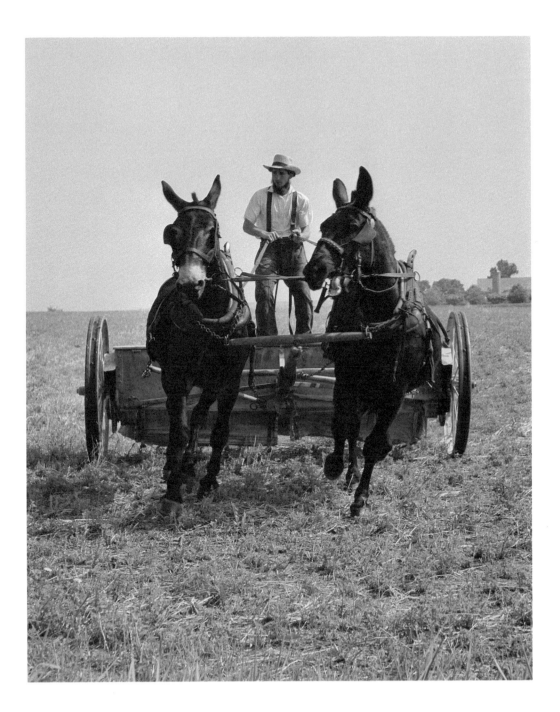

The Amish are rigidly obedient to this rule of plainness, but there is a gain. As between banal or conventional ornamentation, found in so many American farmhouses, and bareness, the bareness is attractive. I've gone from a non-Amish house to an Amish house and have been relieved at the simplicity. With no clutter and with room to move around freely, the spirit (soul) concentrates and feels reassured by the lack of material things. The poverty of the environment enhances its functional design, leaving it visible. Pure.

There must be no large mirror in the house, and Amish must not use bottle gas (some western Amish do) or electrical appliances. They must not have radios, must not go to movies or fairs (but may go to zoos), and must not play cards, though they can play chess.

No photographs!

No ownership of automobiles or tractors. The Amish do their farm work largely with horses or mules and use buggies for getting around. In Lancaster County, two-seated buggies with gray tops are the standard family conveyance, and one-seated uncovered buggies are driven mostly by the young unmarried men, often with great spirit. The pride of and in horses is noticeable, the sharp clop of hoofs, manes let fly, the firm hand on the reins. I've several times seen a particular phenomenon. Where the only seat of the buggy holds just two persons, two girls will be seated and a boy will straddle the inner legs of the girls and will drive in this combined lap of theirs like a Roman charioteer, the girls leaning against him to protect themselves from the wind.

As the general manufacture of buggies died out, it was taken over by the Amish themselves, particularly by the younger people. Buggies are not cheap; a new one can cost considerably more than a secondhand car.

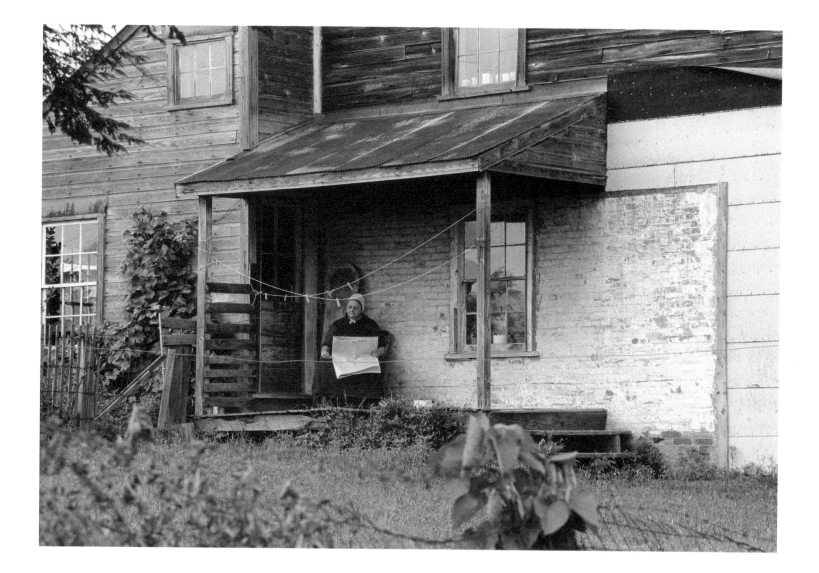

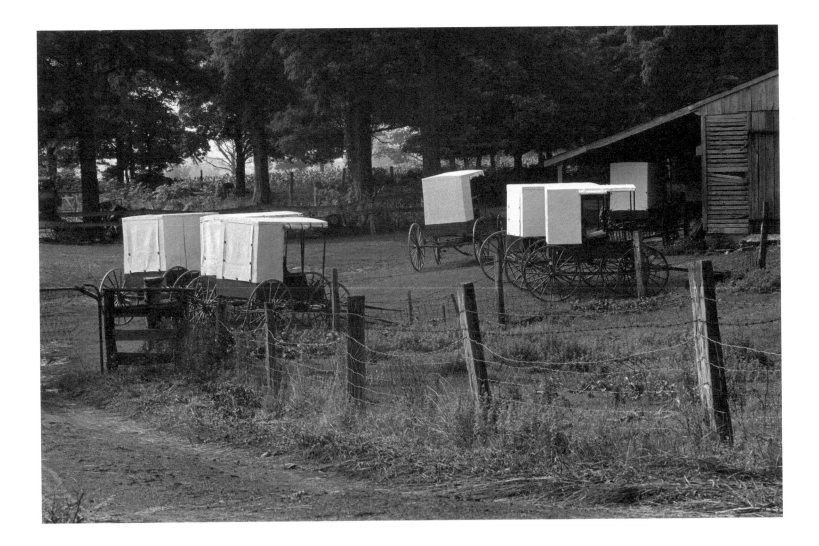

The design of the buggies–dashboard, whip socket, roll-up curtains, brakes–every detail is subject to church rulings. The list of the *Ordnung* (church rules) is endless, and usually unwritten because everybody knows the rules. It is not true that these regulations are absolutely followed or that there is no element of rebellion against them. A few Amish young men may have secondhand cars in town, until they are found out and disciplined. (Unwatched kids learn to shift gears in automobile junk yards.) In the hurry of barn raising, an electric drill may be run in by special wire. An older Amishman may have a transistor battery radio in the barn loft "for the music." But what is important is that none of this is widespread enough to affect the dominant pattern of their life. They remain a community of love, nonviolence, goodness, and simplicity. Being God-loving and custom-obeying, unity comes from within.

Only about five per cent of the Amish break away. This is small. A radiance inside the faith holds them. I've seen a young unmarried man in a parked buggy call to an older man driving by: "Hi, Israel." And the look was one of shared community and affection. Such a young man is not going to break away. He has no will to do it.

The Mennonites, though devout, are more outgoing than the Amish. Like the Amish, the Old Mennonites do not necessarily separate the leadership of the church from a man's other work–usually farm work. Deacons, ministers, and bishops are plain working men. Churches are completely simple, no decorations, just plain walls. No organ. The music is equally simple, unaccompanied singing from two banks of voices, the men's on one side, the women's on the other, and it has a purity of birds, the Tolstoyan voice without artifice.

One such service I attended was a service of baptism, and I was aware of its deep and reverberant meanings for the Anabaptist faith. The minister, the Reverend Elias Kulp, stood before the congregation in a white shirt and white suspenders, no coat (it was summer), and introduced the bishop:

"Today we have the bishop with us. This is a rare privilege. He cannot come often, though he loves the church. I will not take his time, but let him talk to you."

"Brethren and sistern," the bishop said, "you know I was lately sick. It's that, and not that I don't love you, kept me away from you. Today is baptismal day. There is only one to be baptized, a precious sister, yes, only one, but we are glad for the one. Baptism is regeneration. Jesus said, 'Except ye be born again'–well now, what does that mean? That was not understood, you know, no, it was not understood when he said it. Does it mean be reborn physically? No, the meaning is spiritual. I'll tell you what it means. It means now a new element. You have gone fishing. I have too. Yes, I am a fisher of men. The line pulls the fish out, throws the fish out on land, then in a few minutes it dies. It is in a new element. If it is to live there, yes, the gills must become lungs, the fins must become wings, the scales must become feathers. So at the rebirth, yes, all must change, all become different, so that the new life begins."

He now beckoned to a girl who had been attentively listening, and she came up in her white dress and thin knees to receive from the old man's hands the baptismal water. Doves outside chirred. I was deeply moved by what I saw (the whole drama of conscious baptism), and I was further moved when, after the service, I saw men give one another the kiss of brotherhood in the church vestibule.

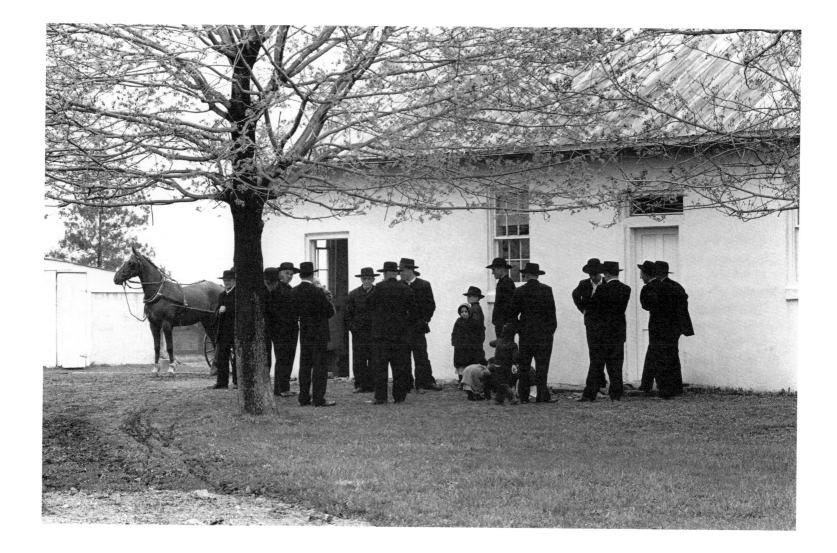

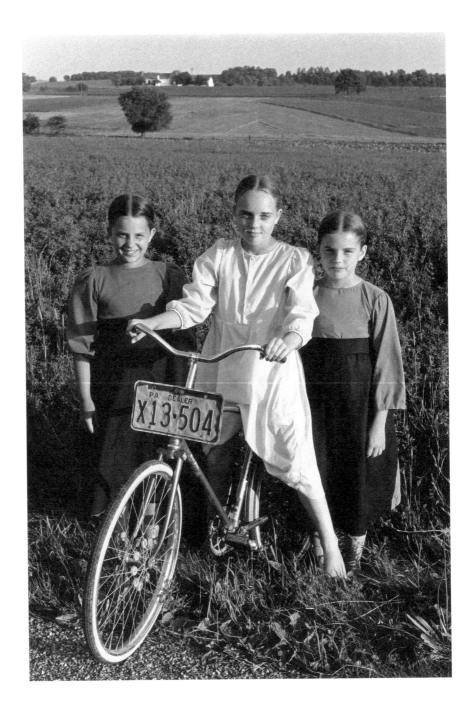

The Old Mennonites, like the Amish, dress simply—no ribbons, no decoration of any kind:

> Mrs. Hertz stands by the door
> in plain shoes, plain dress,
> and the devotional covering
> with its whiteness
>
> falling backward on her hair:
> "for this cause," Paul said,
> that woman was made "for the man,"
> ought she to cover her head,
>
> and yet "have power on her head
> because of the angels." Mrs. Hertz
> has in her eyes the quietness
> of Catharists and Waldenses.

I've heard the plaintive story about the Amish girl or Mennonite girl who picks up a red ribbon in the five-and-ten store and looks at it longingly because she can't have it. It may happen, but what if it does? Is her life without beauty? Does she have no idea of her own values or of the values of the natural and changeless comradeship she shares? In the pleasant faces of these plain-sect women, one looks far to find conflict.

Some modification of the strictness of the Old Order Amish has come from the Beachy Amish, who allow ownership of automobiles and services in church. Mennonites also are less strict. I saw a Mennonite couple driving together in a car one Sunday afternoon with two baby bottles on the dashboard, the mother's cap floating on the back of her head. Sometimes the cap is even taken off. For religionists such as these there is a relevant message in *The Martyrs Mirror:*

"There is more danger now than in the time of our fathers, who suffered death for the testimony of the Lord. Few will believe this, because the great majority look to that which is external and corporeal, and in this respect it is now better, quieter and more comfortable; few only look to that which is internal and pertains to the soul, and on which everything depends."

And here is the credo of the plain sects: "If ye are overcome by the world, it will soon put an end to your Christian and virtuous life, without which latter the best of faith is of no avail. Care, therefore, my dear friends, equally well for both, for the one is as important as the other. Faith without the corresponding life, or the life without the faith, can, will, and may not avail before God. They are like two witnesses, who must agree, and of whom the one cannot stand or be received without the other.

"Knowing, then, that we must care for both, there remains nothing for us but to do it."

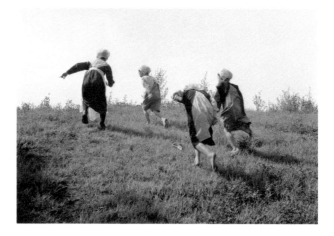

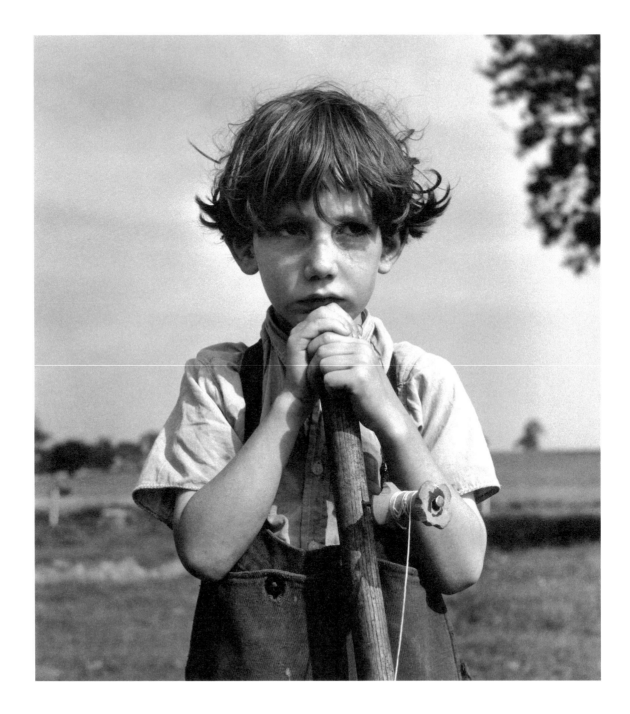

Iᴛ was in the spring that I went for a visit to an Old Mennonite friend. As I drove along the back-country roads, here and there I noticed pairs of pale-feathered mourning doves like moving wraiths of dry grass, small heads lowered into the gravel and dust of the lanes. If they flew, a fan of jagged white showed in their tails. Their four-note song, a long note and three lower and shorter notes, more than any other sound can epitomize the summer's heat and mystery.

As I came in the lane toward the barn and sheds, I passed a close-cropped green pasture littered with the damp tan cobs of corn that had evidently been fed to the sheep now standing in the pasture or sitting together warmly (it was still early spring) in the shelter of the buildings. Their winter fleece was heavy. Their ears stuck out like the ends of a spike driven through the head, and they stared somberly from their dark faces, the fleece thick around their foreheads. A couple of lambs walked on springy legs, but not gamboling really. The weather was cloudy and cold.

Mary Gehman knew I had come to talk with her, and brought me through the large kitchen with its electric refrigerator, stove, and cookies laid out to cool on a work table—to the comfortable living room. This room, furnished with sofa and chairs and a TV, was low-ceilinged and shadowy from the cloudy weather outside. A motto on the wall read: "In quietness and confidence shall be your strength." On Mary's dark hair rested the conventional small white cap, so inconspicuous you hardly noticed it unless you looked for it. She's not a large woman to have ten children. She remains unworn, not oppressed by life, quick to respond, gentle but firm. I knew she was affirmative of eventual values but darkened by some of the setbacks of spirit in the immediate present.

Her husband Abe was away "marketing." We spoke alone. I wanted to learn more about her life.

"What's your birthday?" I said.

"September twenty-third. My birth date? Nineteen eleven."

"Five years younger than I. Where were you born?"

"At Lansdale, a half mile from the entrance to the interchange. I lived there till I was seven. I was one of fifteen children my mother had, but only seven lived. When I was seven, we moved to a large farm near Allentown, and Father bought the first car then. Until then we had only horse and wagon. Then he rented the farm down the hill from here, a hundred acres. The house had two porches, an upper and lower. It was nice. My father also liked it because it had a spring in the cellar. It was a refrigerator, in it we kept butter and milk, and in summer we laid watermelons in it. We had one cow, that I milked. We had a shed with a floor for threshing. You drove the horses in a circle as they used to do, to thresh out the grain. There was a pig sty and over it a workshop. The house was in bad shape when Father bought, and the land needed work. We called one field 'the peach-orchard field' because it had stumps of a peach orchard that we had to take out—typical. I remember one of my uncles saying, 'I wouldn't want to be found dead here.' It was hill land. Many don't appreciate hill land. We had a big raspberry patch; that does well on a hill, so we sold raspberries." (Reddish wands of raspberries that spring so fast and grow high into wild tangles.)

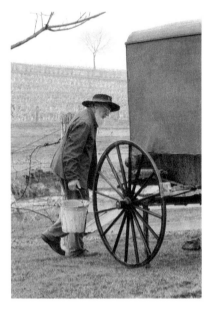

She loved to be outdoors with her father, Elias Kulp, watching him work and helping. She went to the creamery with him. "He enjoyed singing. He sang 'In the Sweet By and By' in German as he drove along, and I still remember the words.

"He was very energetic. He never claimed to have much patience, but he was loving."

When she was about twelve and her father was in his forties, he was nominated to be minister of the Bally Old Mennonite Church. Four drew lots and he was chosen. "He was a good minister, but sometimes the nominations are not made carefully. One nominates a friend without thinking whether he would be good for a minister, and sometimes it doesn't turn out."

Her father began his ministry at once, without special training. "That's how it was in those days. Now there's training." Her father, of course, had to continue earning his living, since that was the practice of the Mennonites. He had bought a fourteen-acre farm of his own up the Crow Hill road on which Mary and Abe now live, and he farmed this and also drove a mail route. As time went on, the church called upon him for evangelical work. Each evening for ten days or two weeks he might be "away," conducting services for conversion and revival, counterpart of the old camp meetings. The place where he preached was often filled to overflowing, many standing, Mary said, and many coming forward for conversion "and uniting with the church."

But when "Father" was away, the farm work suffered: "He couldn't keep too much of it going. And he had to get a substitute for the mail route too."

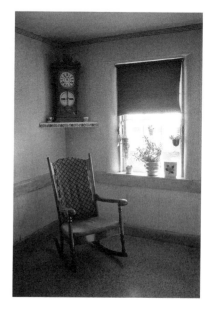

I knew from hearing him that there was a union of strength and simplicity to Elias' preaching. Once I talked with him in the hill house, years ago, and I felt as if an unswervable moral force faced me in his cool, deep eyes. He spoke of the "one church" (of course his church) that followed the early Christians, but he was not exclusive—he told me the story of a Quaker, a young man who in the Civil War

refused to fight, and an officer ordered his men to shoot him. The men (he said) held their fire down, and the Quaker "stood on." The officer tried to ride the boy down, but his horse repeatedly balked, and the boy was saved. "It would seem God loves the Quakers in his design as He loves our own. Not only we are willing to die for Him. Others have that thought too."

A thought that survives yet, that lives in Mary and Abe's own life.

Mary went to school in a small brick building that has now closed, and she took one year (the ninth grade) in junior high, "and I could have gone on, I'm sure, if I'd wanted to, but I just didn't." She was thirteen when she finished, she had skipped a grade, and then she helped at home on the farm and also helped her married sister. During the winter months, she and her mother took work home from the Ribbon Mills, or she worked in the mills.

Abe Gehman was a childhood friend. She had known him since she was nine and had gone to school with him. His sister was her closest friend, and he was in her Sunday school class. When she was nineteen, they "got engaged." They were engaged for about a year, and then, in 1931, at "the beginning of the Depression," they were married.

"We weren't too much affected by the Depression. We were never used to having a lot of money." For four years he continued to work with his father on the "big farm" that had been in his family for six generations. "We had several rooms in the house, it was a very large house–they built big houses in those days. Two sisters and a brother also lived there." And there the first two children were born, Linford and Abe. As it got crowded, and as they wanted to go on their own,

they rented a farm about "a mile and a half from his father's farm." Then Abe came down with tuberculosis and was in the sanitarium for nine mouths, and that wasn't an easy time, but Mennonites help one another and he recovered and they came "here" to the farm. "It used to belong to his aunt and uncle. We bought it for a little over two thousand dollars—in those days one could buy for such a price. We had chickens at first and did truck farming. We both enjoyed raising vegetables, and it took a lot for the family" as the family grew toward twelve. "Abe marketed at Narberth near Philadelphia, that was a long day when he was away, and still is. We raised corn for the chickens but mostly truck." Abe is big and strong, and one would not imagine he had ever been tubercular.

"Last year we raised fifty geese, some from day-old goslings. We pay a dollar thirty-five for one gosling." Amazed, I asked how much she got a dozen for goose eggs, and she laughed. "Not by the dozen. They cost eighty cents apiece." But they get eight and nine dollars apiece for the larger geese when they "market" them.

I asked her about the sheep, and she said, "We have thirty old ones and get maybe thirty-five young ones each year. When they're young, they can be a great deal of care. Sometimes the mothers reject them and I have to feed them by bottle. There are so many that have lambs at the same time, a mother won't take a lamb, or if she has two, she'll reject one. So I have to feed it. The first week it takes time. The feedings are oftener, and the first night I bring them in near the stove, it's so cold. During the night they'll cry and I have to feed them to settle them. Even now they follow me to the mailbox, they still know me." She said, "They graze very close, like deer," and one has to be careful not to let them crop unwatched in the dry

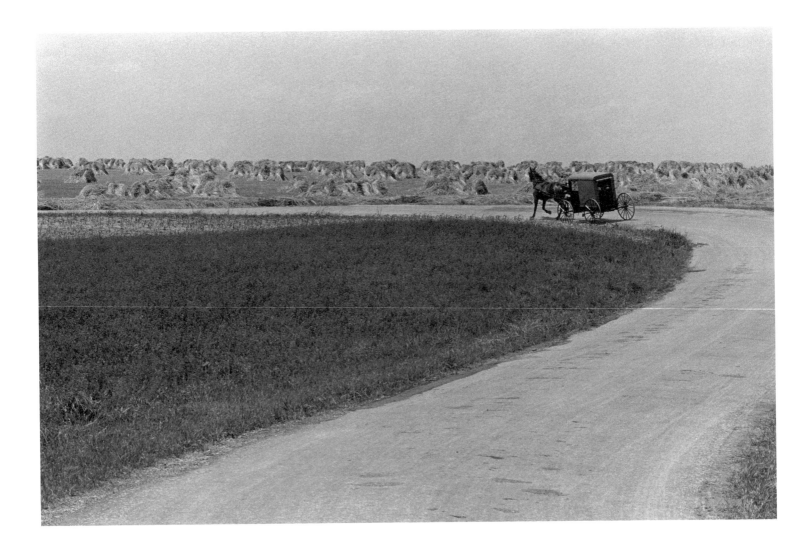

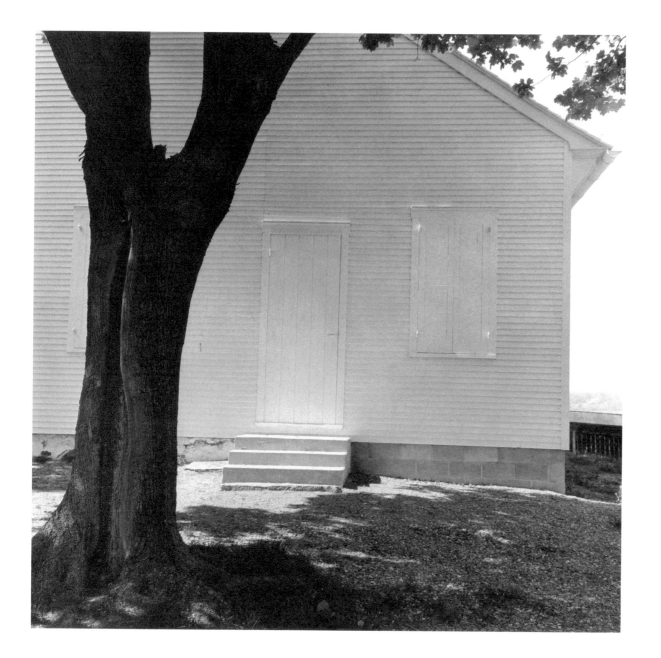

weather or they'll kill the grass. "They also chew off the rose bushes."

Abe shears them "at the end of April when the cold rains are over." He ties the fleece from each sheep in a bundle and puts the bundles in a bag and takes the bags to Reading to the "wool pool," where the wool of the area is graded, weighed, and bought, all in one day. Then the sheep shiver into May.

During this extended talk about Mary's life, we came to Linford (Linny), who is now a medical volunteer in Biafra. A little over two years ago I had visited Mary and Abe to talk with them about Linny, who was at that time a volunteer in Vietnam. It was then winter, with the clean neutral smell of snow and ice in the air. The trees were bare, and the valley was like a wide saucer, with a few silos gleaming on the valley floor and on the sides of distant hills. The Gehman sheep and geese were inside.

Being subject to draft in World War II, Linny worked as a C.O. orderly in a hospital and decided to be a doctor. He took his M.D. and then trained to be a surgeon, and it was as a surgeon that he was recruited by the Mennonite Vietnam Christian Service to go to Vietnam.

He worked in the evangelical clinic in Nhatrang for four years. He learned Vietnamese to be closer to his patients and to be able to talk without the confusion of an interpreter. He did eye surgery, or other types of surgery during emergencies. He wrote home: "We're taking turns operating with Dr. Troyer. I did a discission of a cataract on a seven-year-old Tribes boy this morning while Harold gave ether." Some kind of vital *élan* made him transcend the twelve hours of daily work (or more) and go to the Hôn Chôn rock, a high point where he could look out over the beach at sunset or sing to his guitar "Christ Is Risen." He wrote home how a plane

taking him to a conference at Dalat circled a waterfall. He wrote about "absolute spring" and how he held children in his arms, children who were so quiet and trusting during surgery that it hurt him.

Abe and Mary showed me a picture of him, and as they talked with me in the winter kitchen with its stove half-coal, half-electric (like a symbol of the times), their younger children went light-footed and quietly by.

Now Ronnie, still another son, is in "alternate service," refusing the draft, and is in a hospital in Florida.

So this base of farm life, two generations from the life of an Old Mennonite minister who cherished a congregation of love, each helping the others and helped by the others—plain, local, in a sense communal, secure in one another's affection, and largely independent of the outside world—this farm base has now its close ties with catastrophic areas of the contemporary world. And these ties are still those of love.

"Faith" with "the corresponding life," says *The Martyrs Mirror,* for "the life without the faith, can, will, and may not avail before God . . . Knowing, then, that we must care for both, there remains nothing for us but to do it."

A strong belief in freedom, independence, and what might be called inspired small farming unites these people. Farming is what they deliberately want to do, and I believe they will go on doing it until the roads and towns literally push them out of the way. And they will do it not with any mere stubbornness, but with an inherited need.

The main characteristic of the Pennsylvania Germans since early times has been their determination to stick, to stay—not to exhaust the soil, but to build it, to

rotate crops. The Mennonites and particularly the Amish outfarmed the "English" and after a few generations owned the best land. It is simply a fact that they took over land from non-Germans that was run down or barren looking when they started with it but that was inherently good, and they made it pay. But in part they did it by narrowing their lives, if it can be called narrowing: The Amish dismissed book learning, they gladly dismissed cultural sophistication and commercial skills. And the other sects were cautious, though some had a love of learning.

For the most part these people were small farmers, even in the rich flatlands. They did not hire help or have tenants. In harvest, all members of the family got out into the fields, including the women (and many still do). Neighbors helped one another. Nothing was neglected.

In the old days there were no grass mowers. All was mowed by hand, by scythe, and grain by cradle. As a man, then, would mow, a woman was needed to bind. She'd make a band out of a straw, grab a bunch of it, make a twist, stick it under, and that kept the grain together.

Now things are different. One day I saw an older boy driving a large tractor that was pulling a "shredder," and the shredder, powered by the tractor, was cutting up cornstalks and loading them (blowing them) onto a truck attached behind. The growing truckload defied gravity. I spoke to the boy, who stopped and unloosed the tractor. "I'm not bothering you?" I said. "No, it's time for lunch, about." Indicating the truck of chopped stalks, I said, "What's it used for?" "Bedding for the cows." I asked if the cows would eat the bedding, but he said, "No, but they might nibble." I asked, "Does it pay to have this shredder?" He said it did. They farmed

two hundred acres and used it also to cut up sorghum. "You cut it when it's pretty high and the blade is this wide" (about an inch, as he showed me with his fingers).

It was the fifth of April. In a few days they would begin to plow. On the drier hill slopes, some farmers were already starting. Then, he said, going over his schedule with me, would come disking, then planting. He explained that they rotated corn and alfalfa, two years of one (with fertilizers), two years of the other. Alfalfa is particularly rewarding, not needing replanting.

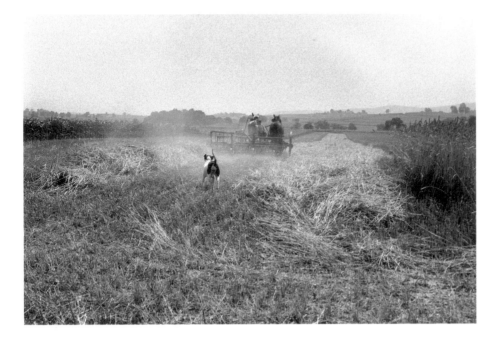

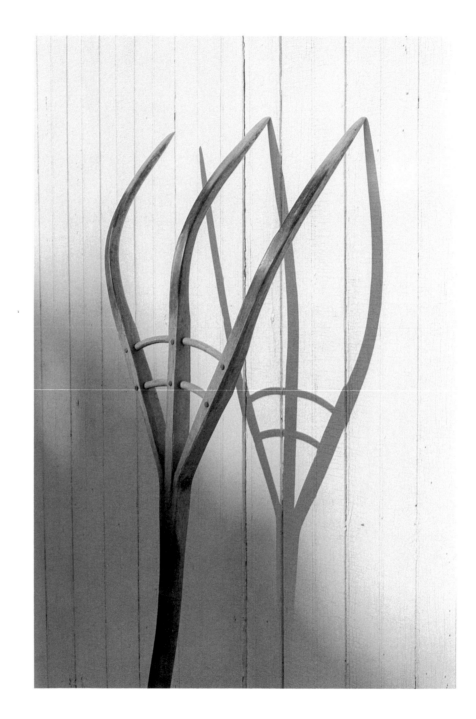

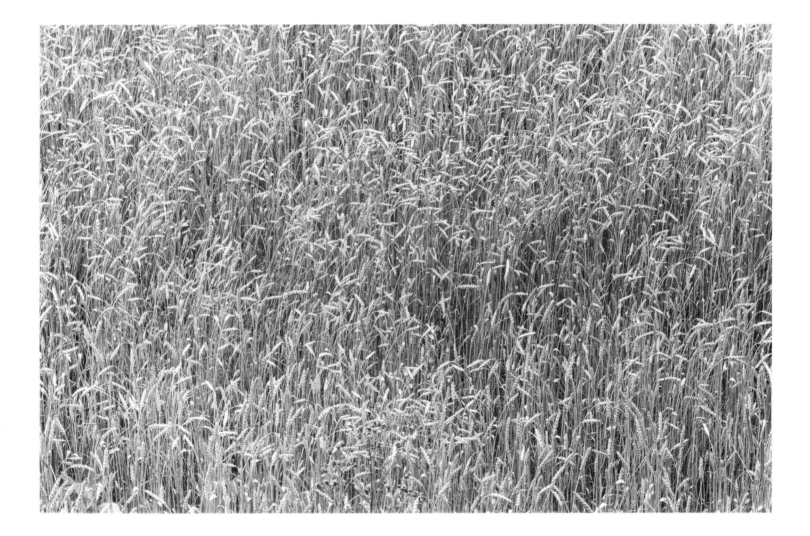

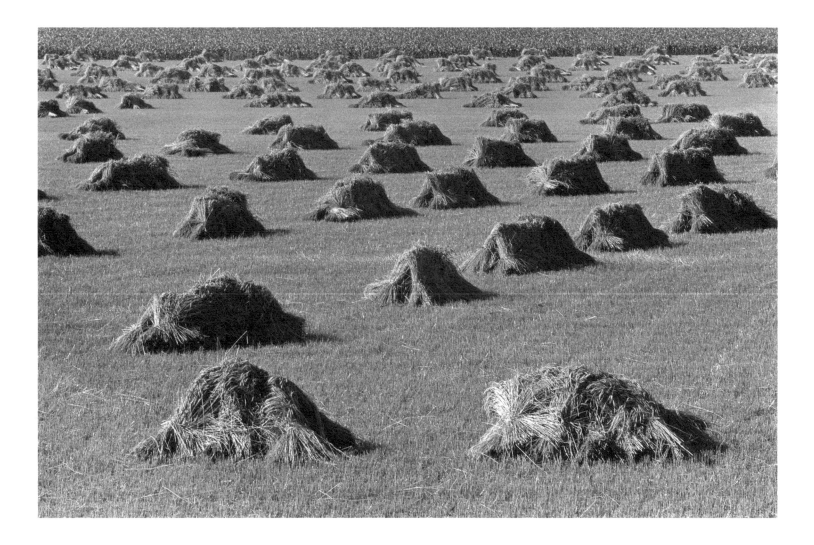

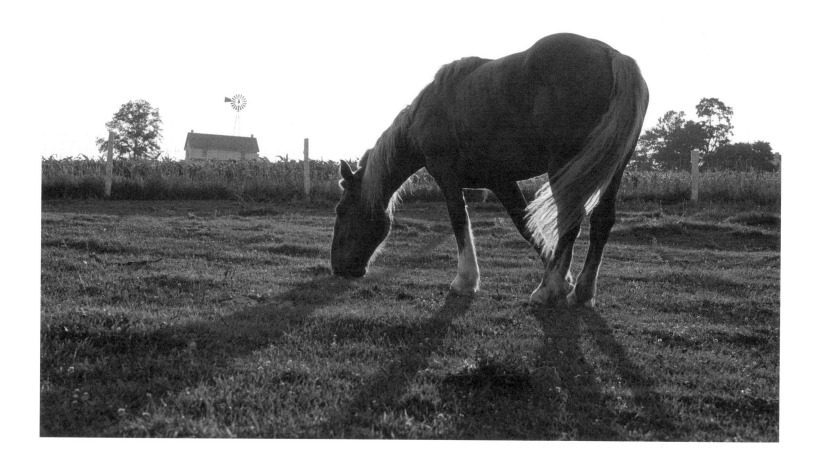

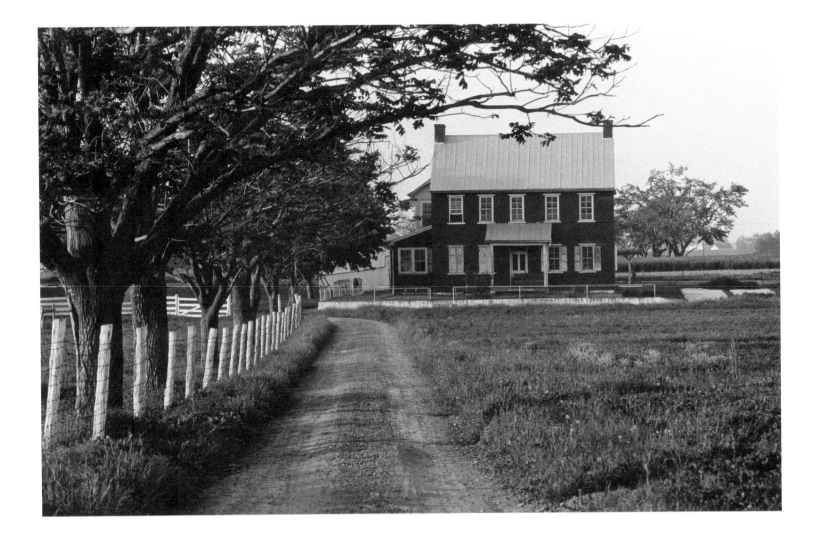

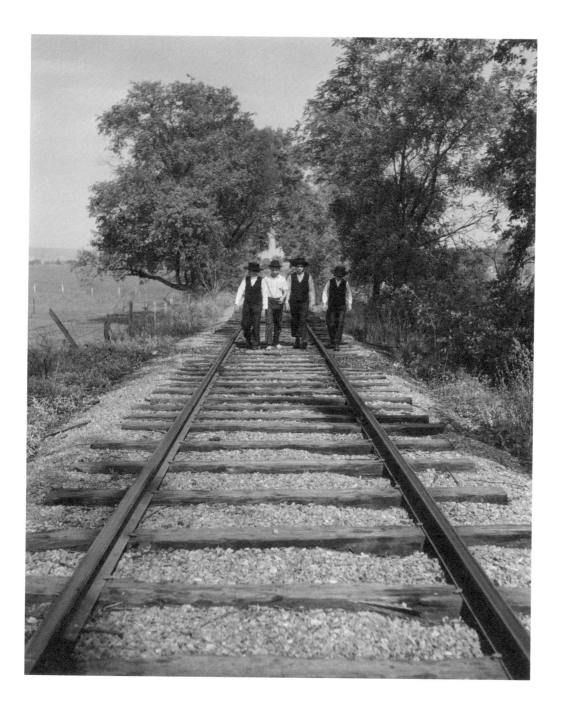

A SPECTACULAR difference between Palatinate-descent Germans and other farmers has been their care of cattle. The Palatines had the tradition of protecting the cattle through the winter. Walter M. Kollmorgen in *The Pennsylvania Germans* mentions how commonplace it was among non-German farmers to leave cattle out all winter so that they died of starvation and exposure or would be "on the lift" in spring, so emaciated and weak the farmer had to help them get to their feet. Nothing like this among the Pennsylvania Germans. They built barns "large as palaces" (and that looked like palaces, as I said) before they put up houses for themselves. They even had a saying: *"Eine gute Kuh sucht man in Stall."*

One of my good friends, Walter Shuhler, is a dairyman. The above-mentioned early Palatine farmers should see Shuhler's dairy farm today. Shuhler is quiet, unaggressive, even gentle, and what has happened is simply a kind of advance, a change like all the irresistible "progress" of our lives.

"To start, we bought about twenty Holstein purebred two-week-old calves." It took two and a half years for these to freshen and come to milk, a significant investment of time and money, but, he said, "I had good luck. All raised all right."

With a herd, it was a question of breeding. A cow gets in heat and stud is needed. But no more the bull as in the old days. No, one calls for "the insemination man," or another name for him, "the technician." This man—there are nine or ten of them—comes with a syringe and chilled semen. "Well," Walter said, "you know how they do it. It's almost like a doctor . . ." Semen is from the purest-bred bulls, ten thousand dollars a head, such as no one farmer could afford. The "insemination man" has a two-way radio in his car nowadays as he cruises the countryside, so that he may be called faster to the bawling cows. And the "progress" is unarguable. "I

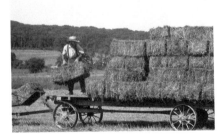

haven't lost a cow in ten years. The herd is strong. No Bang's disease to be spread by the bull. The calves are better all the time."

But Shuhler had known the earlier days: "Cows now don't live so long. You feed them 'top production,' only the best, and it burns them. In the old days you gave them their hay, corn chop, linseed-oil meal, and you turned them out in summer. Now they mostly stay in the barn and you give them silage all year round, balanced feed, measured protein—no, it is a kind of stress. It is too much for them. They break down one way or another."

The product of the feeding is milk, and for that there is now, of course, the electric milker. Udders are cleaned, the strap is fixed over the cow's back, and the milker is adjusted. In five minutes, electric hands have operated and four udders are pulled and drained. The milk is flowing through pipes to the cooler.

When I was a boy, a cat or two usually waited during milking, and sometimes the farmer deflected the stream of milk into a cat's mouth. None of that now. None of that deviation. The machines purr now, and the cats are gone. But in spite of machines, Shuhler's cows remain pets. Each has a name and, he says, a temperament. He talks to them, humors them, tries to make up for the savage bovine automation.

Walter Shuhler and his cattle bring the story of farming to a contemporary end, but it is worth mentioning that, of course, none of this electrical and electrifying improvement is allowed on Amish dairy farms. But that doesn't mean that no change whatever is taking place. The Amish have to meet government or state hygiene regulations if they are to sell fluid milk, and some have put in milk houses and cooling systems run by gasoline engines. The cow stables are remodeled to

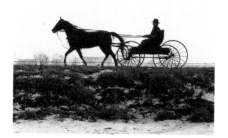

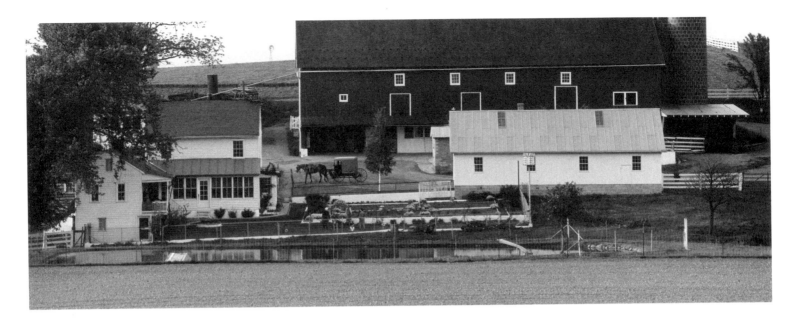

meet the requirements of the milk inspectors. Trucks of large concerns pick up the milk and take it away, the Amish being forced in this way to fit marginally into the larger society.

The Amish are not against all mechanical appliances. Water is commonly pumped by windmills or water wheels put up along a stream. So the cattle are watered and the house can have running water. And there are other ways the Amish fit themselves to the larger society, sometimes leaning on their Mennonite neighbors. Mennonites, for example, will drive them somewhere in a car in an emergency. So the world comes on, rigorously, as the Amish *Ordnung* braces itself against change.

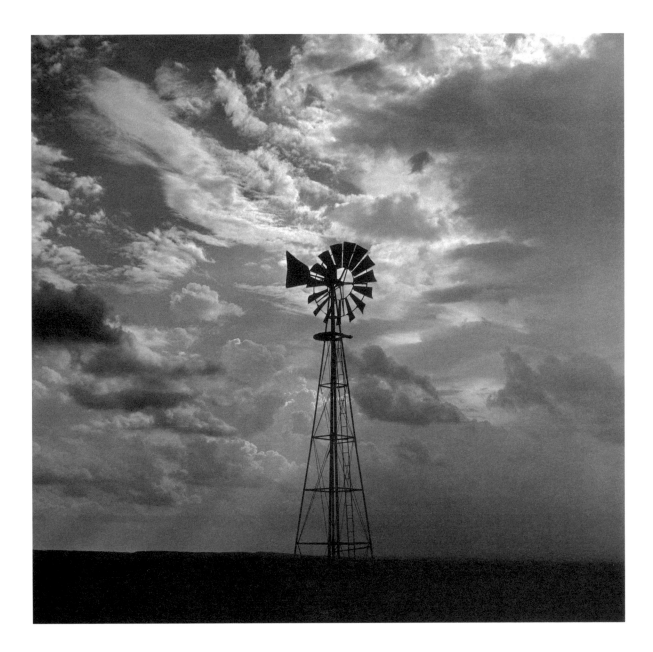

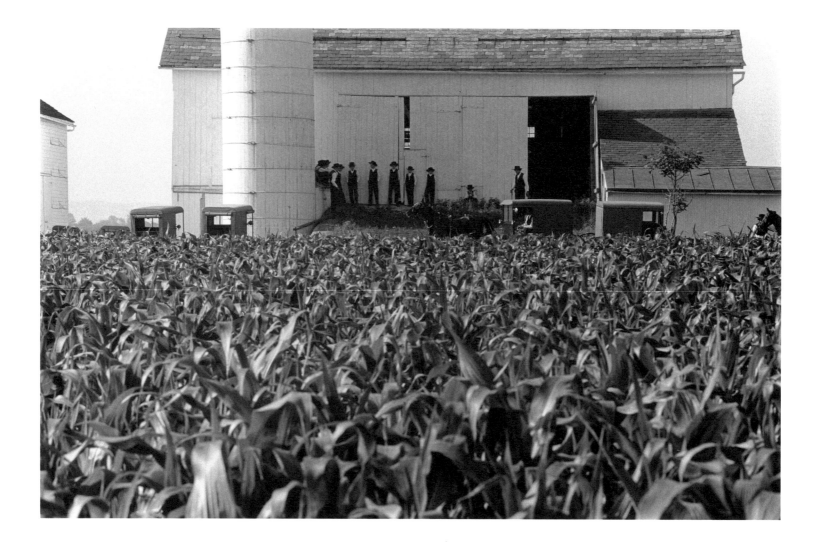

Over near Pennsburg just off the road to Perkiomen Heights, I became acquainted with a man named Milton Longacre, who was a farmer but also a horse trader, a big and kindly man.

He explained to me that the work of a horse trader is or can be an honest one (though he knew from experience with horse traders what all the conniving tricks were). "An honest trader," he explained to me, "hears from a farmer that he needs such and such a type horse, and he finds the horse for him, he performs that service, and he makes a reasonable profit from it."

Milton got his horses mainly from the horse auctions in New Holland. This is Amish country, and their demand for horses supports these auctions, held weekly in enormous barnlike structures on the outskirts of the town. But it isn't just Amish who buy their horses there. You also find at the rail and on the tiered seats "English" farmers and men or women in jodhpurs who want to buy riding horses—even children eying ponies with longing. But at the time I went with Milton, the Amish predominated.

The auction room is a large room like a theater-in-the-round. It has a railed pen up from which the seats go. A wire carries papers from the auctioneer to an office high above the floor at the entrance end. Back from the auction room like a labyrinth are stalls for the animals waiting to be sold. Milton and I walked around looking at the horses with identifying numbers glued on their flanks, and Milton now and then patted one or spoke to one.

We came back to the auction pen. Here in a remarkably quick succession, horses of all kinds are brought in and run up and down, bumping into spectators (or buyers) who are not prevented from edging into the display space. Sometimes

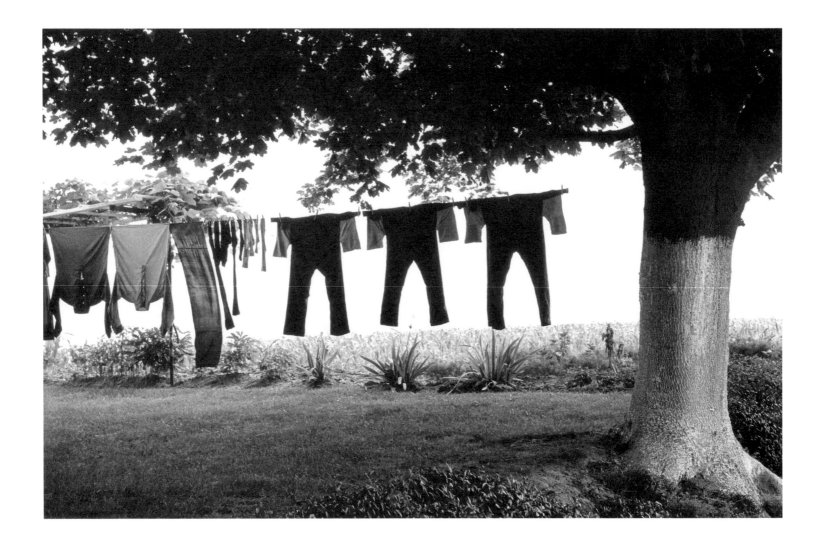

the horse is ridden and raced the short length of the pen. Meantime the auctioneer with the microphone hanging on his chest is intoning: "Sixty-nine I'm bid, who'll give seventy–sixty-nine seventy sixty-nine seventy. Gone for sixty-nine," and his face has a reproachful see-how-low-you-bought-it expression. The animals get auctioned off in a hurry, one or two a minute, so that there seems an unending stream going through the pen.

I heard a non-Amishman speaking to a friend: "They want a small horse to draw their carriages on the road. Yes, ten hundred is as much as they want. They want to skim along the roads. They use mules for farm work."

I thought of the proud sight of the "small" Amish horses clop-clopping ahead of the buggies, heads up in the air sighting on the sun and the horizon. They seem to come from everywhere, crisscrossing the landscape, manes flying and lips writhing with repressed energy. And the gentle faces behind them, of the man driving, the woman beside him, and often a small girl beside her like a young replica.

They do use mules in the fields, but they also use work horses. I've seen four horses pulling a corn cutter at harvest time, with a woman driving and two men piling stalks on the wagon as they pour from a mechanical chute. I've seen a barefoot boy plowing with six horses: these families work.

Now the men stand here watching the auction, in black hats and chin whiskers, like dozens of Lincolns, the bang of hair on the forehead combed carefully down and long hair in back cropped just above the collars.

Somewhat to my surprise on this first visit with Milton, I discovered many of the Amishmen chewing tobacco and spitting, even the young ones, and this seemed a somewhat disconcerting note in the aesthetics of purity. True that in the Lan-

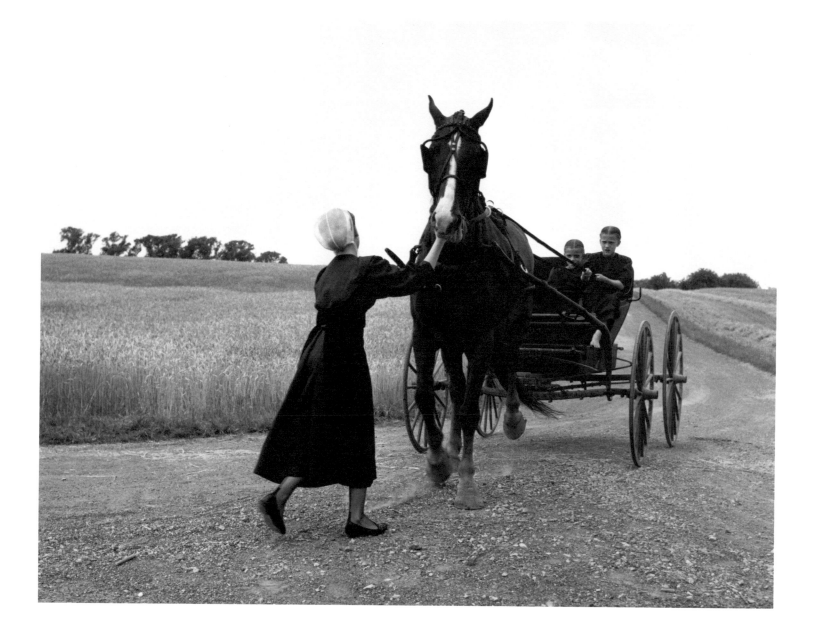

caster area, tobacco is the Amish cash crop. And I had heard the expression: "He stayed for four spits," timing the length of a visit by the number of times the visitor spit out the back door. But it still seemed incongruous to see these radiant-faced religious men spitting.

Somebody said about a pair of horses sold for one hundred and forty dollars: "Cheap—there's a lot of work in them yet."

Milton seemed to have come only for the pleasure of being there. He did say, "Maybe I should have bought a horse. But you don't know how they'll handle. You don't know how they're broken in." But none of that seemed to restrain others in their buying. I heard later about a man who had bought three ponies instead of one, bidding on the wrong lot.

The noise is overpowering and has almost no letup, but under it a man and woman may talk together, and near the entrance I heard a man discussing the purchase of a horse's bit. On a great bank of bales of hay, two little girls sat as wide-eyed as if at the theater.

Asserting the primacy of place, the horses sometimes whinny appealingly from the stalls.

Since that first visit with Milton Longacre, I've been several times to the horse auctions, always with pleasure. The town of New Holland is clean and pleasant, and the surrounding country, either in sun or mist, is covered with an almost unbelievable light.

One thing that I've noticed in this flat country around this horse-auction town is the use of names for roads, the names being up on posts at the crossroads. An explanation may be this: Distinguishing Amish is difficult, there being sometimes

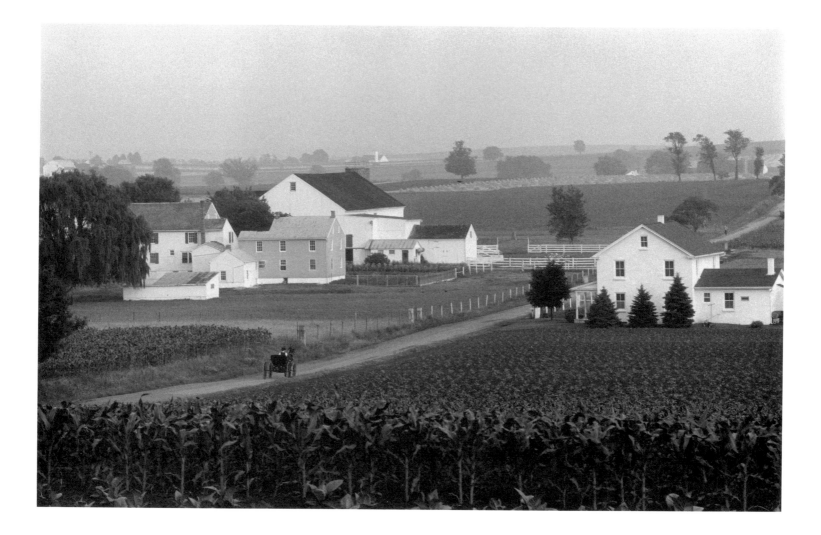

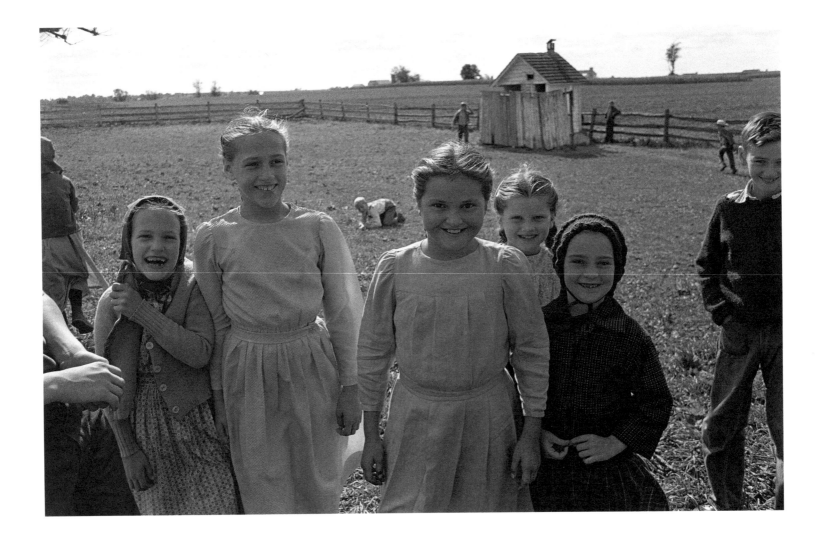

as many as nine by the same name in a single area. (An issue of *Pennsylvania Folklife* says that in one locality were nine Jacob Yoders, nine John Yoders, and nine Sam Yoders.) The roads may help identify and locate them. Another means of identification is nicknames, kept all the person's life (Wild Israel, Waxy Jake, Gishy, Big Elam, Coldwater Dave, Little Chris).

Such nicknames may be based on an event that happened. A farmer told me a couple of nicknames in his family and how they were acquired. When the notorious bandit Bill Wade raided one of his relatives named Schultz, Schultz threw his pocketbook out the window and ever afterward was called Kabilde Schultz–*kabilde,* a man who is "very clever, smart, knows what to do in an emergency." Another Schultz painted an Indian on his barn and was afterward called Indiana Schultz.

The country near New Holland is filled with Amish one-room schools. The one-room schoolhouse used to be an integral part of farm life before buses and consolidation, and its survival is worth looking at. Each Amish school has a bell and is surrounded by a rail-fence yard, complete with boys' and girls' outhouses. Inside the school are usually eight rows of benches, enough to give each primary grade a row of its own. Teachers are often non-Amish and may be much loved. They may be considered lucky to be loved by the faces one sees in Amish schools. The children go out at lunch time, in good weather, eat their lunches in no time, and play games, or full of body vitality, run just for running's sake. Back and forth from railing to railing in waves, or dodging around trees, or throwing leaves at one another in surges of mischief. But if the running and romping stop, a sadness may come over some of these young faces, a look of questioning. Just before class reopens,

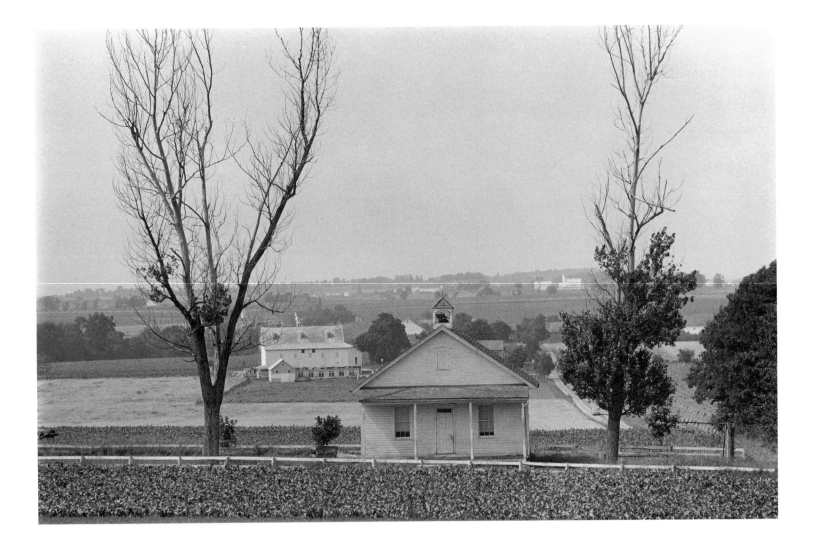

boys may comb their long hair with "fractured and gnarled combs," and girls may stand in a circle, one behind the other, replaiting hair.

In Berks County I talked with a teacher, Daniel Rohrbach, who told me about his start teaching in a one-room schoolhouse:

"I was only eighteen, and I had children from six to fifteen. That was young now to begin teaching, but I was close to the children, I remembered how it had been with me. I came my own first day to school, knowing not a word of English. I remember it rained that day and I sat on that rainy day trying to learn by listening but could not. One must fail by listening only, no? The teacher got hot. Can one hear words when the teacher shouts? I could not. Beatings came later, yes, and fear of that new language I could not learn.

"Well, on my first day as a teacher come the shy ones, the little ones, knowing no word at all of this English now. As I hadn't. I called the class to order, one by one called roll, and the little ones, so frighted by then, could hardly talk. I said a few words in the dialect, and it was comforting to them. Yes, they spoke better then, I could understand their names. So I made the start of teaching. I set the older ones to copying and called the little ones up front. There was a row of them. I told them they must learn English. Had they some words of it yet? *Ja,* they had, *ja ja ja.* So they said even if they hadn't. I told them they could surely learn. 'Look.' I took the chalk to the blackboard, we had only a black-painted board then, not the slate blackboards one has now, and I drew a picture of an apple. 'Apple.' *Now sag,* 'Apple.' *Un now sag,* 'I have an apple.' Well, so that first day came to an end, and the little ones then knew 'I have an apple.' Yes, each one could then go home, knowing at least the few words.

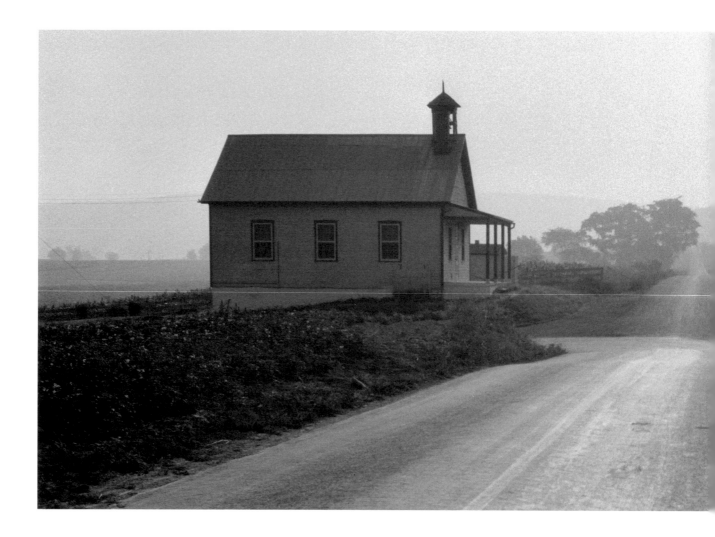

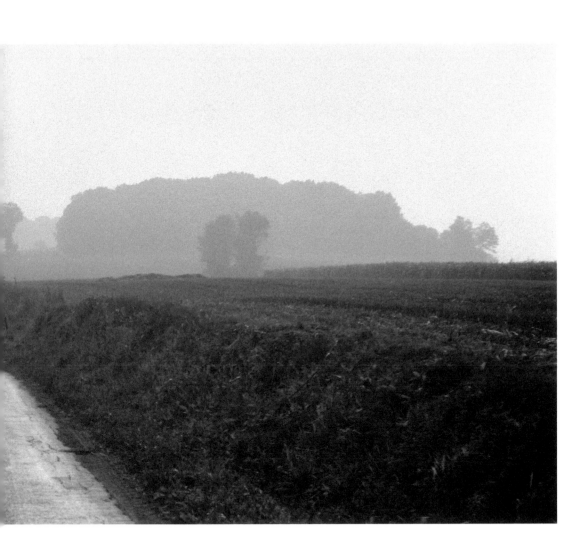

"As I began, so I kept on, and I would not say it was so hard, no, not so hard at all, as if I had used the cane."

This degree of gentleness isn't unusual. I talked with several men and women who had it, and I suspect the quality was common in all schools of the area, not just the plain-sect schools.

Today, except in Amish communities, the one-room school is just about obsolete. When, near Hereford, for example, a large consolidated school was built, the one-room schoolhouses of the country roundabout were closed or sold and converted into homes. One of the teachers in the consolidated school, Edwin Fox, was a beekeeper, and thinking of his hives, said to me, "Did you ever see a round schoolhouse?" for the new consolidated school was round like a beehive, and the children ran in and out like bees.

The Amish are against consolidation, for this is too threatening a mixing of their children with outsiders, and most states, including Pennsylvania, have let them keep the one-room schools in their own communities. But in the mid-sixties Iowa tried to coerce them: Buses and school authorities arrived at an Amish school to bring the children by force to the consolidated school, and there was a distressing scene of frightened children running into nearby cornfields and parents arrested and taken sobbing to jail. The authorities thought a few days of this would settle everything, only to find, as is common when violent methods are resorted to, that the Amish were willing to stay in jail and pay fines that would ruin them financially rather than have their children go to "consolidated." The issue was compromised. The Amish kept substantially what they wanted.

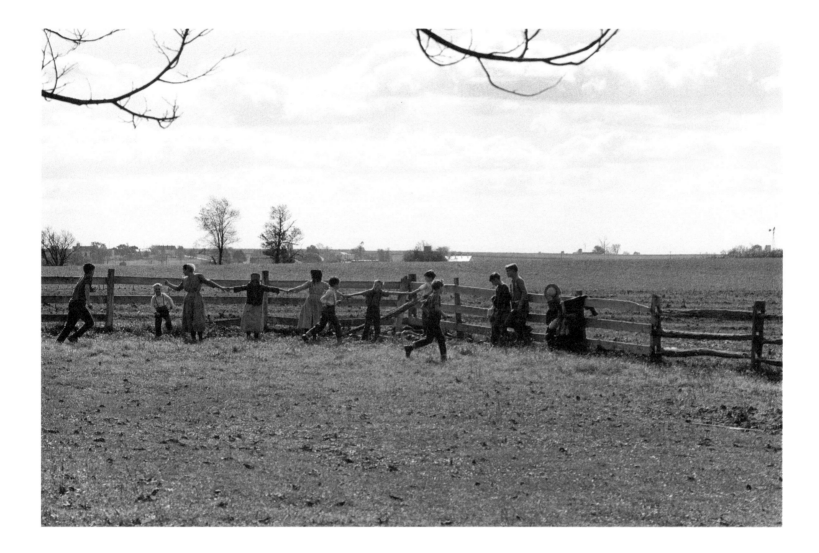

Amish frown on any "pleasure" from learning (or reading). Happiness, to them, is following their own way of life, and all the education needed is the minimum preparation to be farmers. After the eighth grade, the most the Amish accept is "vocational" training on a limited basis. They know there is little likelihood of the survival of their way of life unless they follow this pattern.

Mennonites encourage higher education and have their own colleges, such as those at Bluffton, Ohio, and Goshen, Indiana, and have their own high schools in the same areas. The attractive hold they have on their young people is self-giving to others, the attempt to put the teachings of Christ into actual practice in outgoing service. All undergraduates at Goshen now, for example, are required to give one year of church-supported service in an underdeveloped country as part of their education.

Higher education, of course, has an important role in the over-all life of "the area," and there are many colleges and schools in and around the larger cities: Franklin and Marshall College in Lancaster (and the Thaddeus Stevens Industrial School for boys), Albright (Evangelical) College and an extension of Pennsylvania State College in Reading, Muhlenberg College and Cedar Crest College in Allentown, and Lehigh University and the Moravian College and Seminary in Bethlehem. Through these colleges and their staffs, the world intrudes on what may seem to be (but is not) a provincial area. Ties of spiritual rebellion link it back to Europe, and a love of learning (in spite of plain-sect rejection) has been persistent and typical.

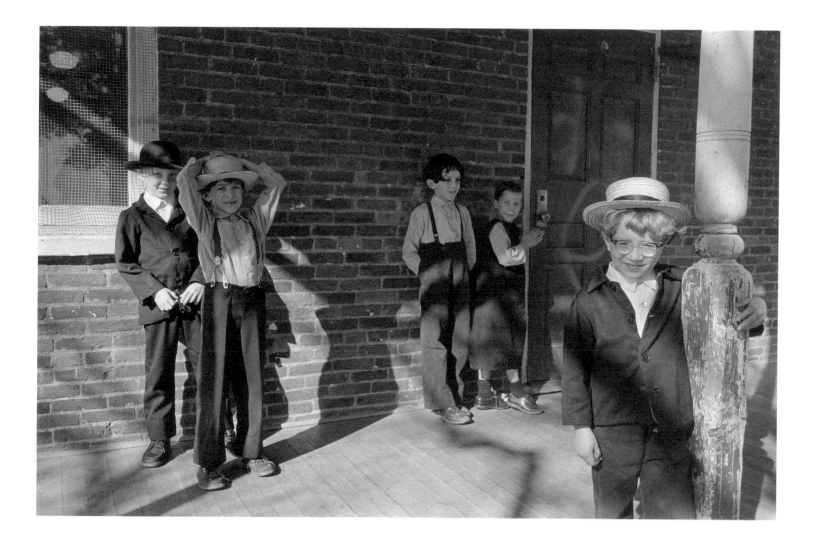

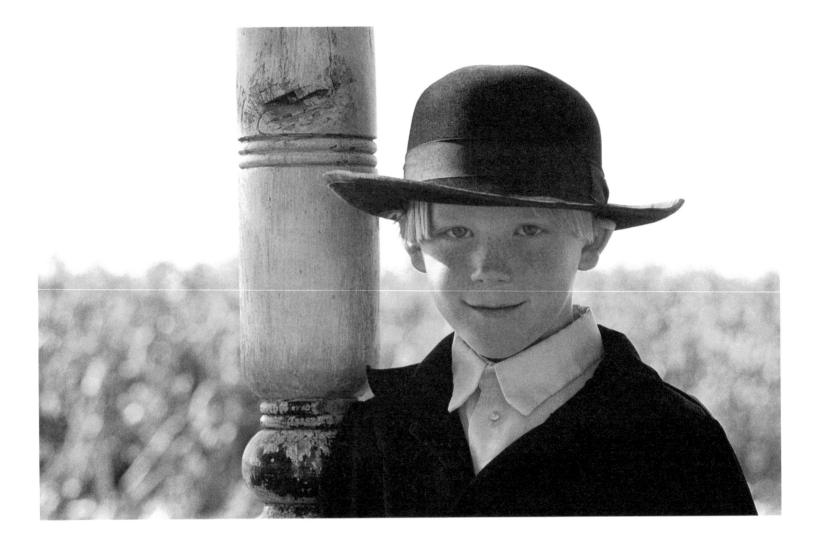

One evidence of it, and a happy flowering of local democracy, is the debating or literary society. A generation or two back, almost every small town had such a group. Under its auspices, farmers, teachers, storekeepers, "mechanics," even housewives gathered forces one evening a week for a highly charged debate. Question: "With which foot did Julius Caesar enter Gaul?" Question: "Before the Civil War, who had the greater cause for complaint, the Indian or the Negro?" Even a local matter like the lengthening of the school term (touchy for farmers who depended on children for work) was debated. Particularly popular (in this pre-TV era) were evenings of declamations in English and in the dialect that created a gale of cultural pleasure.

Part of the literary society's value was a re-estimation of the *Deitsch*. Always formalized or standardized languages dominate, and dialects and vernacular are looked down on. But the dialect may turn out to be a secret treasure house, a way of entering the hearts of the people. In Germany in the early 1800s, Johann Peter Hebel wrote poems in the dialect and was admired by Goethe (who himself was criticized for "South German" vulgarisms in his work). The Hebel influence spread through Germany and Switzerland and even reached America, where already in Pennsylvania, dialect writing was beginning–verse, love letters in rhyme, articles.

In my library (and much prized) is a stained mauve-brown cloth book with a gilt harp on the front, wrapped in a band that says *Harbaugh's Harfe*. This *Harbaugh's Harfe* is the main source and inspiration of dialect poetry among the Pennsylvania Germans and is so loved that it is now a part of the general consciousness. It has

only fifteen poems, but many a school child has recited two of the most famous, *Das Alt Schulhaus an der Krick* and *Heemweh:*

> *Ich Wees net was die Ursach is—*
> *Wees net, warum ich's dhu:*
> *'N jedes Johr mach ich der Weg*
> *Der alte Heemet zu...*

Harbaugh translated four of his poems into English, but the English makes a poor showing beside the *Deitsch* (could you appreciate Bobby Burns in English?).

Henry Harbaugh was not only of German descent, but of the German romantic temperament. He was the great grandson of an immigrant who came over in 1736 and settled on Maxatawny Creek in what is now Berks County. He had a strong mystical feeling of some intimate meaning in nature and life, and as a boy would stare at birds flying or collect legends when he should have been loading logs. A friend, Dr. Philip Schaff, sensed his talent and urged him to write in the dialect and preserve a sense of the living community before that community disappeared. The *Harfe* not only did that, but led to an outpouring of poetry in the *Deitsch.*

Harbaugh was a minister of the Reformed Church. The poets who followed him included Charles Calvin Ziegler, Astor Clinton Wuchter, and Eli Keller, and then a Catholic organist of Allentown, John Birmelin, whom Harry Hess Reichard, in a study of Pennsylvania German writers, called "probably the most versatile writer that has ever assayed to use the dialect." This opinion was shared by Dr. Preston A. Barba of Emmaus, who brought Birmelin forward in his *"Pennsylfawnisch Deitsch Eck"* (Pennsylvania German Corner) in the Allentown *Call.* By the time I was

aware of Birmelin as a poet, he was dead. Dr. Barba and Birmelin's son Martin helped me examine his work, and it had the authentic voice, an infinitely moving immediacy. Allentown is a place of hills, and Birmelin wrote of the *Haerbschtwind* that "murmured on the hill and roared in the *valley*"—*rauscht* and *braust,* like a contradictory lullaby. In Allentown he worked in a silk mill as a weaver, played the organ in the Church of the Sacred Heart, and listened to the immanence of beauty around him. One of his poems had the title, *En Silwrich Waard-e-Weilche un en goldich Nixli*—this was something a *Pennsylfawnisch* mother would say to her child waiting for a promised thing: "A silvery wait-awhile and a golden nothingness," and his sense of the values available to him made him notice it.

He had a great love of children. He translated two hundred Mother Goose rhymes into the dialect. Instead of "I went to London to visit the Queen," "I went to Macungie to visit your sister." As he worked, the dialect flew free and then it seemed to come to look at itself, to hear itself. So he whispered to it:

> *Unser sheeni Mudderschprooch:*
> *Pennsylvaani Deitsche waare*
> *All de viele viele Yaahre*
> *Reichtum, Seegge fer des land.*

> [Our beautiful mother tongue!
> The Pennsylvania Germans' gift
> All these many, many years–
> Riches and blessings to this land.]

His son told me: "Father'd spend an entire day just to kick one word out of a line." He also said, "My father did all this work for love. He never had a thought of payment and never made a cent from poetry all his life." So he wove, so he rolled out his threads–real words, real stories of the emigrants, ballads, Susannah Cox, Regina Hartman, poems of the Palatinate, poems of the people come here to their own hills and graves, *An de Baerrick Maria Ihrm Graab,* songs for children to dance to, songs of the changing months, songs of both light and sadness with a laugh misting off to rain.

T H E dialect produced storytellers, playwrights, and essayists, but the essence of it is poetry where the words sing, where they have an inevitable rightness. There is reason why poetry is the possession of one language only, particularly when it's the "in" language of an intimate working group. And, in this instance, of a loving group.

When local men and women talk with you, they slip into their own way of expression almost in spite of themselves. *"Ich bin eens fon denne des der eesel aus der wandt g'schlage hut."* "I'm one of those kids a mule kicked out of the wall." Asked where his grandfather came from, a man said, "A crow laid him on a stump." (This might be related to the expression "up the stump" for being pregnant.) Such earthiness allies the dialect with another derivative of German–Yiddish.

The Pennsylvania German delights in confusions that arise between English and *Deitsch.* Somebody says, "There hops a toad." The High German word for "death" is *"tod,"* and the dialect is close to it, *"dod"* with a long "o." The dialect speaker says, in comment, "Oh no, he isn't dead if he hops."

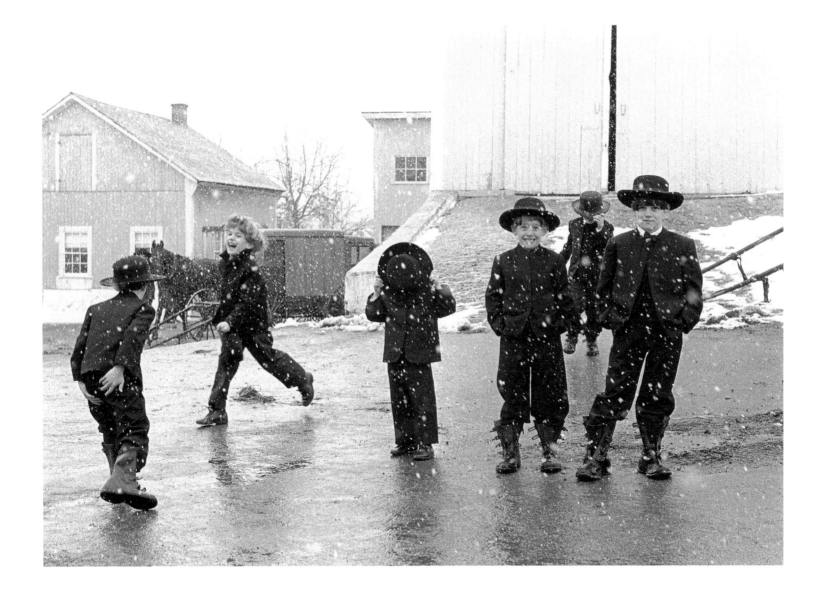

A city man (it's always a city man or a rich man who must be made a fool of) comes to the country looking for a housemaid. He hears of a farmer with several daughters who might do, and comes to the farmer and says, "I'm from the city and need a maid. I'd like to hire one of your girls." The farmer chases him off the place. The word "hire" is "marry" *("heire")* in the dialect.

The *Deitsch* has lent itself not only to poetry but to music. And the Pennsylvania Germans have an inherent love of music.

A potter years ago told me of making a glockenspiel of two full octaves from the different-sized pots in his father's pottery, and playing it as a child. He played a German waltz to which the potters danced.

Most of the towns had a local band, and some of the town bandmasters had considerable talent and composed marches. Some towns had quartets and local singing groups. A favorite song was Luther's great hymn, *"Ein feste Burg ist unser Gott"* ("A Mighty Fortress Is Our God"), that hymn that comforted emigrants in so many moments of danger.

My friend Ralph Berky told me recently about a phenomenon that still continues: the farm family orchestra. He had one in his own family. "Father directed it and played the first fiddle. Lillian Berky was organist, and Herbert was assistant organist and pianist. When he wasn't called upon to do that, he played the second fiddle. I played the mandolin. Down on that farm was Alfred Stauffer. He played the first fiddle. Elias Stauffer played flute. On that hill beyond Clayton was another Stauffer family, and the two boys played the violoncello, the small big fiddle about this high, and at another farm about a mile to the east, toward Bally, the Pennypacker farm, was Ulysses Moyer—he played the cornet. My older brother, the doc-

tor, played the cornet if he wasn't too busy with office work . . . Well, we went from house to house on Wednesday nights, sometimes it was here, sometimes down there or up on the hill—boy, it's a wonder this house is still standing, the noise we made."

The Amish enjoy singing, and in their enclosed society it has an integrating and sustaining function. Their *Ausbund* has only the words of the hymns, not the music, and the "tunes" (tones or modes) have come down orally for two hundred and fifty years. They probably originate from Gregorian chant or plain song, and are sung slowly. A four-verse hymn may take anywhere from eleven to twenty minutes to sing. But the young people have a faster singing when they get together on Sunday evenings and may, as they become relaxed, switch to singing in English.

LIFE in the area is not just country life. It is also town and city life. A local friend of mine, Percy Hertzog, drove some twenty miles in to Bethlehem most days of his life to work in the foundry there.

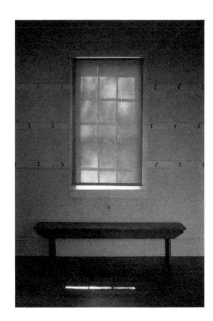

Approaching Bethlehem, particularly at night, you see the foundry furnaces burning, their fires and illuminated smokes (red, mauve, crimson) painting the horizon. This is Bethlehem Steel, where Percy worked, a strange industry to have grown up in this quiet place.

Bethlehem—one of four large cities in the area—was named for the birthplace of Jesus and owes its naming to Nicolaus Ludwig, Count von Zinzendorf, a great figure among the sects, who was born in 1700 in Dresden, Germany. Zinzendorf's grandmother was a strong religionist and took to the Pietist idea of "little churches within the church" that would purify and be sources of improvement. As

a child under this influence, Zinzendorf had such enthusiasm that he wrote letters to Jesus and threw them out of the window, "hoping that the Savior might find them." In 1722, just after his marriage, he offered his estate at Berthelsdorf as a refuge for the Moravians and began to learn from them and finally became their leader.

Then he was condemned for his views (and their views) and was exiled for eleven years. His followers had to emigrate, and one group made the long trip to Pennsylvania and pushed up the Delaware to the fork of the Lehigh River and made a settlement there, and there Zinzendorf followed, arriving, as it happened, on Christmas Eve, 1741. His Moravians sang about Bethlehem, and he named the settlement that.

The next year he came again in warmer weather, with his daughter Benigna, and preached to the Indians, sleeping in their tents. Although he went back to Europe, the Moravians by the substance of their beliefs (with its parallels in Indian belief) and by their outgoingness successfully continued his work. Teedyuscung, later chief of the Delawares, was baptized, and Moravians and Indians lived side by side in a community called Gnaddenhutten (Huts of Grace) further up the Lehigh, and intermarried. Christian Frederick Post married Teedyuscung's daughter-in-law's sister, for example (and later, singlehanded, caused a decisive break in the Indian alignment against the British in the French and Indian War). The Moravian experiment was one of the great attempts at a possible common life of whites and Indians "to the greater glory of the Lord." It was not to endure.

Early Bethlehem–Moravian Bethlehem–lived as a community in an *"Economie"* or "economical household," in which duties were shared. They had brother-

and sister-houses at first, for the unmarried men and women. Marriage was by lot, which was to allow God a hand in the choice of husband and wife, and these marriages seem not to have been any less happy than others. There was a strong interest in music, the favorite instrument being the trombone. For years a choir of four trombone players would play early Sunday mornings from the steeple of the Moravian church, and at Easter they would go through the streets at about three in the morning, to awaken and assemble the people. By 1870, Handel and Mozart were sung in the church by a choir accompanied by organ, two first and two second violins, viola, violoncello, double bass, two French horns, two trumpets, trombone, and flute. Today Bethlehem is noted for its annual Bach festival.

Christmas always has been a time of particular tenderness and celebration in and around the city, not only musically with a song loved by the children–"Morning Star, the Darkness Break!"–but with a custom called *Putz*. One of the townspeople told me about this: "In my day, in my childhood, older people had a way to show the children the Christmas story. The grandfather went out and got a tree stump and hollowed the side into a cave for the scene of the nativity. *Putz*, yes, now that comes from *'putzen,'* 'to polish.' All year it meant that, but at the Christmas season the meaning changed, yes, then it meant to decorate, to make such scenes for the children. The figures they carved of wood: the shepherds, the camels, the star, the heavenly host–four or five, maybe half a dozen, little angels hanging from a blue night sky by blue threads. Then was the stable, the city of Bethlehem, and last, the flight into Egypt, six scenes. That was something now to make wonder the eyes of the littlest children. On Christmas Eve, a basket of moss was brought in and spread on the floor around the sheep and shepherds. Yes, the

smell when the moss was sprinkled was sweet. Then in the morning the little ones, before dawn, came carrying beeswax candles so the light fell on that stump with the Holy Child and on all that had been made, but more it lighted up the children's eyes."

The children would go from house to house and from *Putz* to *Putz,* continuing and sharing their joy. Today a hundred-foot electric star shines over Bethlehem at Christmas, on South Mountain in the night sky, and the "caves" and nativities are less likely to be folk art.

Allentown, which is close to Bethlehem (and has Emmaus in its outskirts), has a less spectacular history. Its site was merely bought by a man named Allen in 1735, so the town was named for him. Its Zion Reformed Church (the town was mainly settled by Lutherans) hid the Liberty Bell during the Revolutionary War. Today it's a quiet, clean city with columns of plants and flowers down its main street. Not least of its honors is to have been for the most of his life the home of John Birmelin, the poet.

Allentown also is the home of the newspaper that has probably had the most notable history of continuing interest in the dialect, the *Call.* Though printed in English, for years it kept on its staff the famous dialect reporter, "Pumpernickle Bill" Troxell, who went out into the surrounding countryside and picked up stories most reporters would never see–how a hired boy plowed into a stump and stuck there–and wrote them up in a highly personal and humorous way in the *Deitsch.*

He and the *Call* had an important part in founding the custom of *"Versamm-ling,"* a large get-together for an evening of singing, telling folk or other tales, making speeches, and generally enjoying the dialect. This custom spread to other

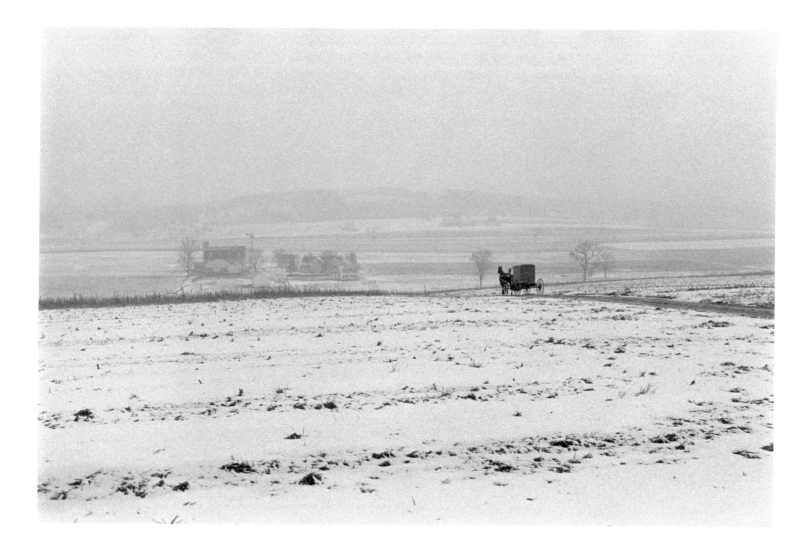

cities. But the great institution of the *Call* was the *"Pennsylfawnisch Deitsch Eck,"* a weekly column published for well over thirty years under the editorship of Dr. Preston A. Barba. This column encouraged creative work at a high level in the dialect and became a source of knowledge of the Pennsylvania Germans that had international interest. I had occasion to feel the sadness throughout the area when the column terminated. "We read English and speak German" is something you will hear locally, and the printed dialect is now fading.

Reading, county seat of Berks County, like Allentown was settled largely by Lutherans, and William Penn's sons incorporated it as a town in 1748, naming it after the English city that was the original home of the Penns. It was to become the third largest industrial center in the state.

On a hill above Reading, a Chinese pagoda looks down over a large flat valley with rows of flashing roofs. In the center of town is a memorable street intersection, Penn and Seventh, across which run some railroad tracks leading into a narrow-walled cut surmounted by a small bridge. This was the scene, in 1877, of a riot during the long-remembered railroad strike of that year. Trainmen were out in ten states. Reading at first was peaceful, but news of the killing of strikers in Pittsburgh stirred up anger, and cabooses were set on fire and coal was shoveled into a barricade. Watching the excitement was a young boy—Howard Cramp.

That night a regiment of Pennsylvania Volunteers, untrained and nervous, were called in, and when the Coal and Iron Police defected (or were cautious), the soldiers alone faced the crowd of "rioters" at the intersection. The strikers threw rocks. Rocks poured from the walls of the cut, and the soldiers lowered their guns.

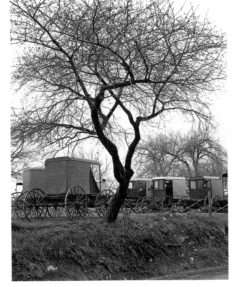

At a command, "Fire!" they fired. Lewis Eisenhower fell, shot fatally through his femoral artery, another through the eye. The cut and the street gutters filled with the dead and dying. The curious boy Howard Cramp was carried into a drugstore and bled to death there. An inquest deposed: "Bullets like lightning cleared the streets and dispersed the crowds."

Today the place looks quiet enough, unlike a scene of violence, and one can walk only a couple of blocks from the cut to the small shop of Frank McLoud and Son, "Manufacturers of Fine Hats." This shop makes hats for the Amish. The Amish make their own straw summer hats, but their dark felt winter hats have to be made commercially, and McLoud makes them. What much interested me is that he told me he shipped them to "every state in the union," and allowing for this as a possible exaggeration, it does mean that the Amish today, dispersed by the hunt for land (and tolerance), have groups sizable enough to order hats in many unsuspected places. I would like to have seen his order books.

He has been in business for a long time and enjoys his special skills. He told me he recommended that an Amishman have three hats, "one around the barn, one for good, and one for Sunday." I had heard these hats were strong enough to feed a horse from (or even at need, water a horse). He seemed not too enthusiastic about this thought, but said they were strong. He gave me a loop of the black felt that might have been cut from a hatbrim and asked me to try to break it. I pulled with all my might and made no impression on it. He said to put it under my foot and pull. Even with this advantage, I couldn't break it. He gave it a hard pull himself with his strong arms. "No, it's strong," he said.

He gave me a quick series of measurements for hatbrims: "A wedding hat is three and a half inches, but generally they reduce it some afterward, to three inches, say. Boys have brims two and a half inches to three inches." He also gave me the heights of crowns. He said boys needed a new hat every year. But the men keep their hats a long time. I could see in my mind's eye young men whose large hatbrims were deliberately curved against the sunset, and older men wearing their hats less flamboyantly as they gathered to talk. And here were the piles of hatboxes and hats around me, and a man proud of his workmanship and honesty.

I visited several of Reading's large bookstores and its public library housing a hundred thousand volumes, and I found that talk on "the hill" is likely to go easily from baseball to Kafka. Reading likes to read and is not a plain-sect city.

Lancaster, on the other hand, is. It's a center of both Amish and Mennonite leadership, and benefits from an agricultural area that is one of two highest-ranking in the country in the per-acre value of its crops (its tobacco, an Amish money crop, has the highest per-acre value anywhere). Lancaster was settled early, and in 1717 became the largest inland city in the colonies. For one day it was the national capital—on September 27, 1777. The courthouse that was used as the Capitol has since been torn down, but a model replica of it stands in Buchanan Park and, I'm told, houses gardening tools for the care of the park.

The city has one of the country's largest stockyards, from which steers occasionally break loose, and as one person put it to me: "They may look skinny in the yards, but in the streets they look awfully big."

The same resident said the city is defined by its odors. "One of them is the foundries, that burn coke and limestone, and another is the smell of half-burned

cigars–" this may be a subjective description "–when the farmers bring in their leaf tobacco to be weighed and sold."

In the famous Lancaster farmers' markets, not too many stalls are handled by Amish, but they come to buy, and their horses and buggies can be found outside. And inside, a young boy will trot along by his father or grandfather *(Grossdawdi),* shy and attractive under his hat and cap of hair. The stalls overflow with fresh vegetables–string beans, cabbage, beets, bunches of asparagus like Inca crowns, potatoes, corn–the overflow of an exceptionally good earth.

One town in the area is widely known mainly from what went on there some two centuries ago–Ephrata. A phenomenal Pietist emigrant, Conrad Beissel, in 1732 settled in a cabin on the bank of a stream the Indians called Koch-Halekung, den of serpents, the Cocalico. Others followed him, and the resulting religious group (actually Seventh Day Anabaptists) created the phenomenon known as the Cloister, just outside of present-day Ephrata.

Much of the Cloister as it existed in the eighteenth century has been restored (or survives), and it may be viewed daily in the company of a white-robed "sister." It is one of the outstanding treasures of the colonial period, the buildings being the finest examples of medieval architecture in America. The main buildings, the Saron convent and the Saal prayer house, have sharply sloping roofs that drop down three stories in a series of small gables, unpainted, time-darkened, and unparalleled in their simple splendor. They are made completely of wood, even to the door latches.

Each floor of the Saron has three common rooms, and each common room has off it, usually, six "recluse cells." Each cell has nothing but one small window, two

wooden sleeping benches, a shelf, a cabinet, and a few wooden wall hooks. But each gives a sense of simplicity and harmony. Each has plain scrubbed wood and white walls, with slight curves of the wood, and must have offered its occupant secrecy and symbolism as a shading of the spirit (the proportions of the room were mystically ordered) and a great sense of consolation and peace.

By 1740, eight years after the founding, the Cloister had thirty-six single sisters and thirty-five single brothers, and its total membership was nearly three hundred. This enlarging group driven by the force of ascetic spirituality developed a level of the arts not duplicated elsewhere in the colonies at the time–*frakturschriften* (some of it still preserved), furniture, great examples of printing (the Cloister artisans put out the first colonial edition of *The Martyrs Mirror,* the largest single book printed in Pennsylvania before the Revolution).

As if this were not enough, Ephrata made a contribution to world music. Thomas Mann tells the story in his novel, *Dr. Faustus,* in six pages or so of Chapter VIII. Beissel invented a completely original system of composition based on a series of four-note chords, the first and fourth notes being an octave. His "free, fluctuating rhythm" proved to be highly effective for setting prose to music, so he composed chorals based on literal, unmodified Bible texts and at one point was about to launch out into a total conversion of the Scriptures into song. The singing of these fresh, pure, utterly harmonic melodies was as original as their composition. The tones imitated instrumental music, the singers scarcely opening their mouths, and the sound by some miracle seemed to enter from above and hover over the heads of the assembly.

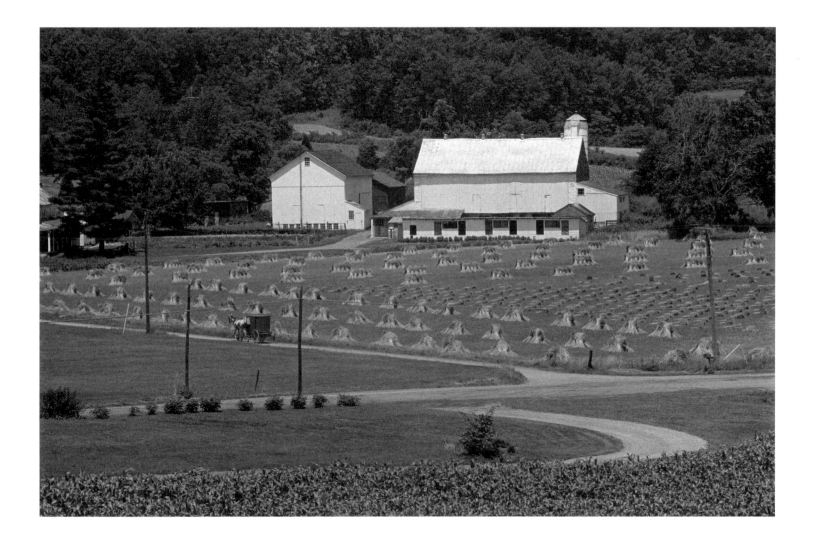

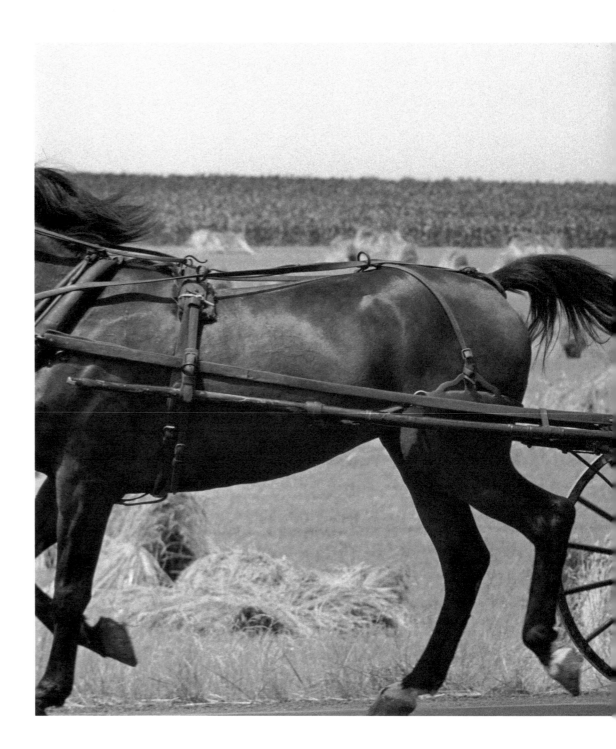

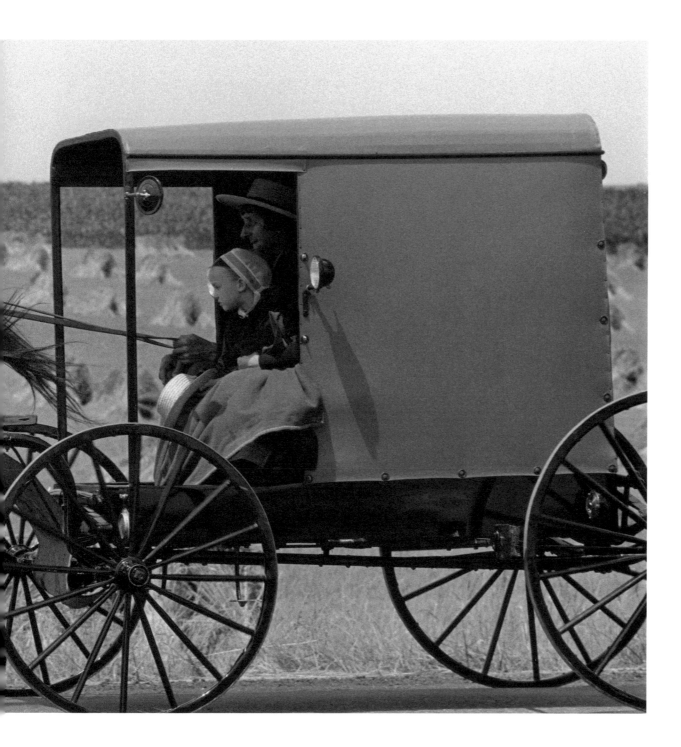

Ephrata now is a place of pilgrimage, a strange relic of religion and repressed humanism, a flower of the sects. The pure expression of the sect was in decline forty years after it was established, and gradually died out, but the Cloister remains.

ONE bright, clear Sunday afternoon in late fall, I deliberately looked for an Amish farm to visit in the rich central Lancaster plain. From what I had heard I was not sure I would be welcomed, but I wanted to try. I came up over a rise in the road and saw a plain white-painted farmhouse with a barn behind it and a tobacco-drying shed, a neat layout like a piece of old-time *fraktur* work. No wires ran in to the house–the owner evidently did not use electricity–and at the back of a circling driveway, near the barn, were several Amish buggies.

As I drove the car in and parked it, leaving room for the buggies to pass if necessary, I was aware of activity in the house. Women and young girls were visible through windows in a kind of outkitchen, moving around. I knocked on the door to this room, which had some glass panes, and saw a bearded man push his way between the women and open the door.

"Hiyah," he said, looking at me with some caution but no apparent fear.

I introduced myself, saying I had never visited an Amish family, and asked if I might visit them. (I had given my credentials as being of Pennsylvania German descent.)

"Yes," he said. "Come in."

His tone was pleasant and yet with a touch of reserve. It was hard to define this reserve. It was like a cock pheasant who lifts his head watchfully in the fields, and

there was a reddish sheen to this man's beard, a touch of feather shine. He seemed intelligent and quiet.

He introduced me to an older man sitting in a chair who, with his white beard, had the look of a patriarch. As I was being introduced and shaking hands, a little girl in a lavender dress put out her hand toward me and smiled, and I put out my hand to her, and she laughed but didn't take it. An older girl in a pink dress and an apron—a pretty child—smiled. "What's your name?" I said. The man said, "Her name is Sarah."

As the children disengaged themselves, I said, "They're sweet."

I got no response to this.

I thought of my grandmother's name, Sarah. That name is much out of use now, but the Amish names still derive openly from the Bible. Here in this removed German country are the Biblical names of the Jews: Isaac, Abraham, Sarah. My host's name was Benjamin. He introduced his wife, Ruth. Another pleasant, slightly taller woman came forward and took my hand and said, "I'm Rachel." She (I learned later) was Benjamin's sister. I liked the unaffected way she introduced herself. Both women wore dark clothing and warm high-laced shoes and the filmy head-covering. They were temporarily busy in another part of the house, and Benjamin dropped his lanky form on a couch near the stove and indicated a chair for me, between him and the patriarch.

A half dozen green plants grew in pots in the windows, swelling with afternoon light from the west. A boy wandered in and out, the usual miniature of a man. At one end of the room, to the left of a door going to the closed-in outkitchen, was a sink with two faucets. I said to Benjamin, "Does your water come by gravity?"

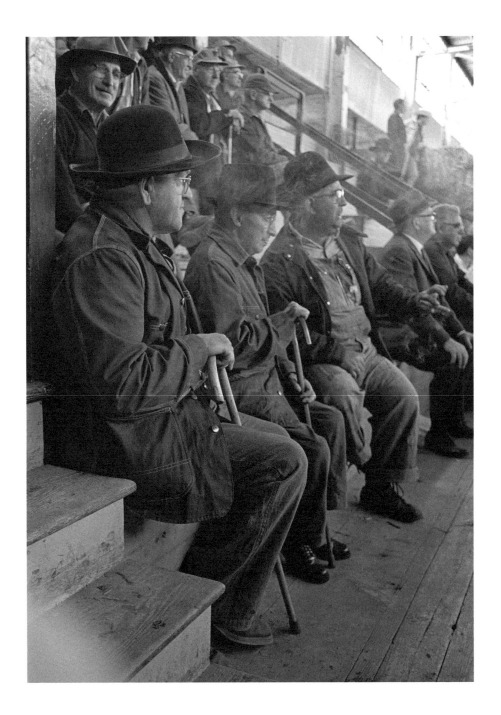

"Yes, it does. I have two tanks in the barn, one of three hundred gallons and one of five hundred. The water wheel pumps the water to them."

I said, "That's large."

He shook his head. "It's not so large," he said. "Some have ten thousand gallons. It's windy today. The windmills are pretty busy all over, filling tanks."

And in fact I had passed many windmills with their high circles revolving in the wind, uttering a faint rattle of wands.

Benjamin and the patriarch said a few words in the dialect. A third woman appeared with Ruth but wasn't introduced to me. She spoke to Sarah, who evidently was her daughter. She spoke gently.

Benjamin said to me, "Do you understand the *Deitsch?*"

I explained how my family had lost the dialect, but I said I understood a few words. *"Cum esse."* ("Come eat.")

He smiled. "Yes, one knows that," he said.

I asked him how large his farm was. He said ninety-two acres. I asked how long he had had it. "Since I had it from my father," he said. "It has been in the family since my great-grandfather. Four generations."

"Always the same size?"

"No, thirty acres was sold."

"I see you raise tobacco."

"Yes, that's the money crop."

"How much does it bring an acre?"

"Well, in a good year, five hundred and fifty dollars an acre. Some years less. Five hundred. Four hundred fifty. This is a good year."

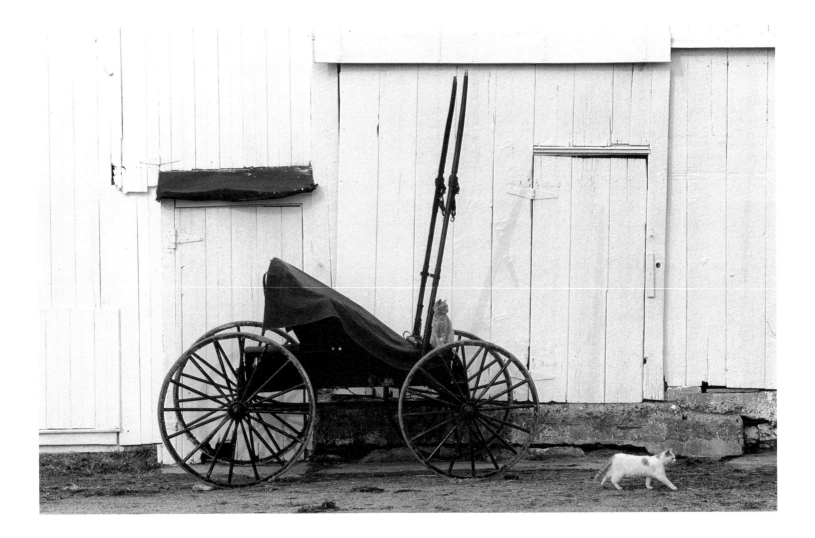

"What else do you raise?" I asked.

"Mostly corn and hay."

"What do you make on that?"

That wasn't a good farming question. "That we feed to the cattle," he said.

"How large a herd have you?"

"Thirty milk cows. We sell the milk from the tank, every two days. We also sell eggs."

Since the fields were now mostly bare and winter was coming, I asked what he did in winter.

"Oh, care for the cows and strip tobacco." He explained that stripping tobacco meant taking out the stems: "Then we bale it and take it to be weighed."

While we were talking, his wife had come and seated herself in a rocker near the stove. Sarah was playing with the little girl, whose name was Susie ("Susih" is closer to the way the Amish say it). Sarah booed Susie and flapped her apron at her with quick little shakes. Ruth restrained Sarah when she showed any sign of roughness. But never lifting her voice. Susih ran to the door of the outkitchen and opened it and hid behind it.

I saw a lamp hanging from the ceiling over toward the sink. It had a large white glass shade and a wick. "Is that an oil lamp?" I said.

"Gas, gasoline," Benjamin said.

"Does it give a good light?"

"Very good–when it works."

The patriarch smiled. He said something. Evidently it had come time for him and his to go home. He politely shook hands with me and excused himself and put

on his coat to go outside to get the buggy. Meantime the woman I had seen earlier (who, I found out, had been visiting Benjamin's mother in another room) came and dressed Sarah for the outside. She put on her a coat and a cape and a big black bonnet, Sarah smiling. She wrapped a plain bright woolen scarf around Sarah's neck and began putting on her mittens. Susie said (if I understood her), *"Heiss."* I said to Benjamin, "Does she say 'warm'?"

"Yes," he said, pleased.

The closed buggy came up past the windows to the door outside and waited. Now I made my big social blunder. I said to Sarah, *"Auf Wiedersehen."* Everybody smiled. I found that what they said was "Bye-bye," as in English. They all kissed Sarah affectionately, and as she and her mother went out the door, the buggy moved forward two or three feet to where they stood. They got up into the buggy, and I heard the wheels move and the horse clop–clopping away until the sound receded. I had noticed the typical proud bearing of the horse, shaking his mane like a lion's on the wind.

So these people visit, so they make the landscape live with their coming and going on Sunday.

Now that Sarah had left, Susie trotted to her father. She climbed up on the couch, and he turned on his back, and she threw herself on him, crying, "Daddy, Daddy," and hugging him. (Maybe she said, *"Dawdi,"* but it sounded like "Daddy.") He kissed her in the hollow of her neck. As she started to get down again, he caught her between his legs. She laughed and tried to pull free. She did finally get loose, but it was now a game and she let herself be caught and locked up several times. I said, "You've started something. They keep on with anything like

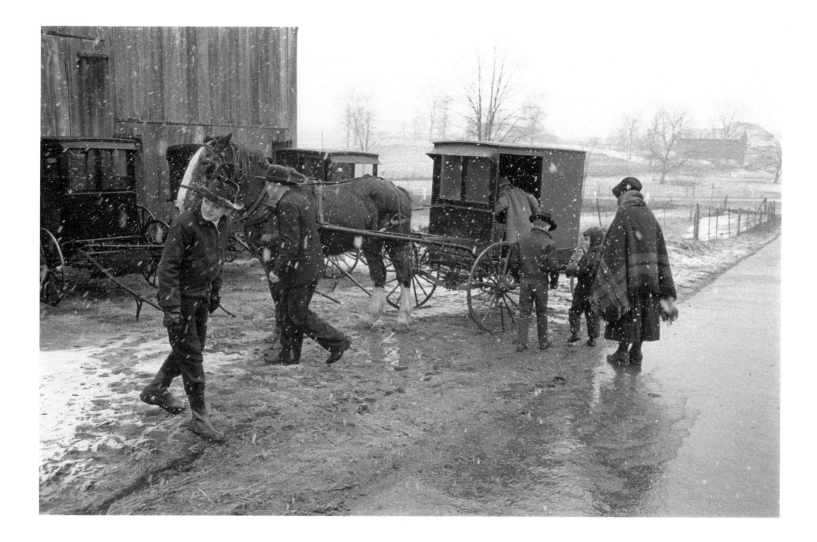

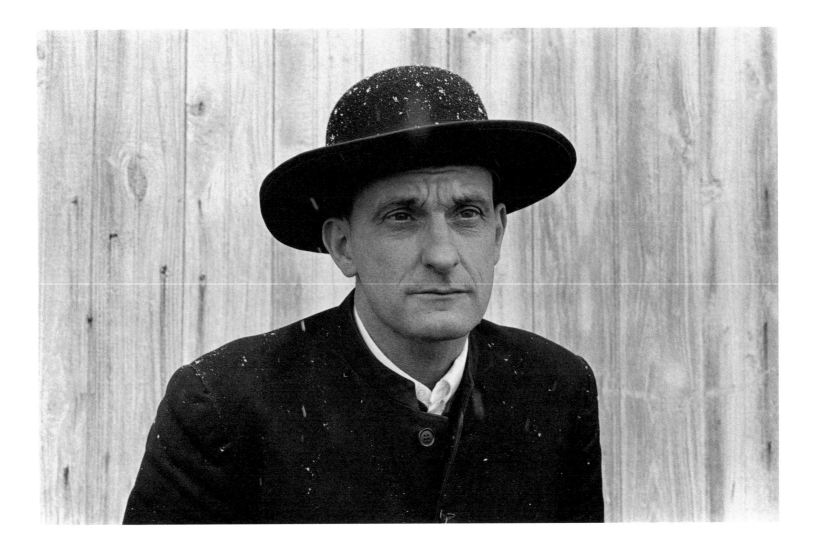

that." I could say it without Susie's understanding me, for so far she knew only the dialect.

"Yes, I'll wear out before she will," Benjamin said. She got loose and jumped up and down behind him, her little dress floating and revealing her white stockings.

There was a great sweetness about her.

I wondered how typical this playing was. I had heard Amishmen were usually reserved and undemonstrative. In fact, Benjamin seemed curiously reserved in some inexplicable way, as if his goodness (transparently visible) was guarded by a caution that would be difficult to describe–almost by a kind of apathy. I thought that this might be a result of his not having the habit of outgoing communication. But then again it might be me, the stranger, who inhibited him.

But now, contradicting this impression, he asked me a few questions:

"Where do you live now?" he asked.

"In New York City."

"You have an apartment?"

"Yes." I thought of my three-room apartment. "I live in a building without an elevator, where I walk up."

"What rent do you pay?"

"Fifty dollars a month."

"That's reasonable," he said.

"It is," I said, "because of rent control."

I had to explain rent control to him, that up to two hundred and fifty dollars a month, rents are controlled in the older buildings and the landlord can't raise your rent.

He said, "You mean rents are more than two hundred and fifty dollars?"

"I know apartments where the rent is one hundred and fifty dollars per room per month, so for four rooms it costs six hundred dollars."

I've seldom seen such a look of shock. He said, "Why don't they come out here and buy a farm!"

His wife had been listening, and she, too, shook her head (to pour money away!). I appreciated their sense of values and had no defense for the Sodom and Gomorrah, the Babylon of cities. And the pure wind spoke at the windows and murmured over the pure land. Which, in my mistakenness, I would soon be leaving.

"Do you have heat?" he said, glancing at the stove.

"I have plenty of heat, fortunately."

As if reminded, Ruth got up and vigorously shook down the large, all-black stove and opened the top and poured in a bucket of coal. It interested me that the woman, not the man, did this chore. Benjamin said that a pipe went upstairs "to a register—that heats upstairs. We have oil heaters in the other rooms."

I asked him if he had brothers and sisters. He said he had five brothers and two sisters, one with him and one married. "Do your brothers farm?" I said.

"Yes, they all have farms."

"How did they get them? Did they save the money?"

He laughed. "Oh, they get bank loans and other loans. But it's getting harder. It's crowded through here and the price of land is high. A thousand dollars an acre—more." Some go elsewhere. I had heard that some Amish have moved to Perry and Center counties where land is only three hundred dollars or so an acre.

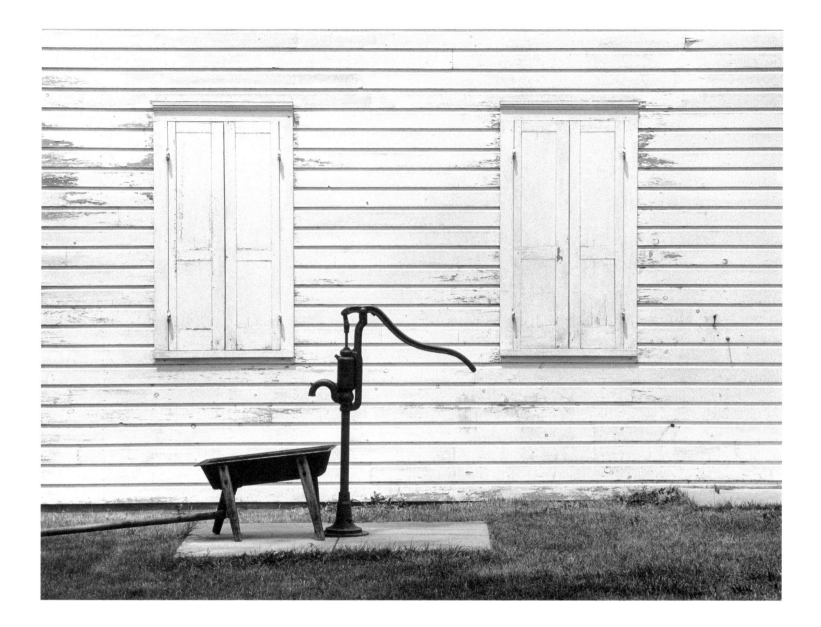

Some move further away, to other states, and so families get separated. If they go away, as some brothers and sisters do, it becomes hard to visit.

Lee Bausher, who told me about this, also told me how expensive it is (or wasteful, from his point of view) when an Amish family buys a farm with modern "improvements." The electricity, the fixtures, outlets, lights–all are torn out. They're paid for to be given up.

And now Benjamin told me of a more fundamental change that is going on, more fundamental than spreading to new farmland. Some of the Amishmen who don't want to leave their families and relatives are beginning to work in town, "in factories, do welding, do carpenter work and so on. No, they have to." They are caught in a religious contradiction: They have a high birth rate (which their church encourages), and the more they grow, the more they press against the "gay" world and enter it. Already some attitudes are modified, as in the greater acceptance of some forms of insurance and travel.

But Benjamin didn't seem concerned. His faith was untouched, and his neighbors would survive some "carpenter work and so on."

Reluctantly at last I said I had to leave. He seemed regretful. With warm handshakes all around, they said good-by to me, and even Susih gave me a "Bye-bye."

Just before I closed the car door, I glanced back at the house and saw the water pump, balanced by a big cement block and an empty milk can, going up and down, up and down. Tock-tock like a heart. And in the windows the green plants glowing.

I had thoughts as I drove away. I was first grateful to Benjamin and his wife for the quiet and peace of the Sunday afternoon and for their acceptance of me in

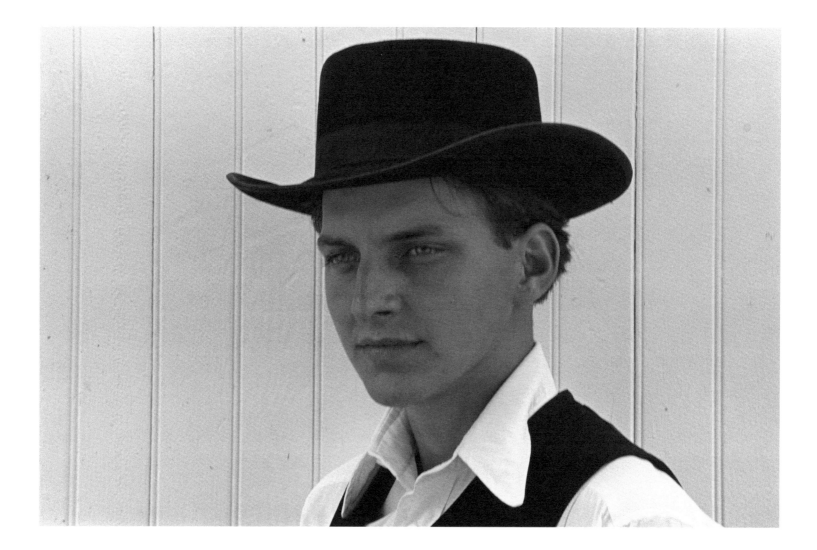

letting me, a stranger, visit. But this closer acquaintance with an Amish family gave me new thoughts I had not anticipated. I felt a lack. I felt in these men and women a touch of naïveté, a limited something, even a limiting something.

These good and innocent people live in a world of possible atomic destruction. Their challenge is mainly disaffiliation and withdrawal. Such withdrawal, good or well-intentioned as it is, leads to a subtle cooperation. They pay taxes even if they refuse benefits of social insurance (God has established governments). Battery lights are used on the backs of buggies at night (electricity required by law). I had seen them twinkling along the roads. They use roadside telephones. Admirable as the Amish alienation is, even healthful, it is also less than a complete answer in a troubled world. There is a possible emptiness to the murmuring and beautiful landscape.

I felt this again when, on this same trip, I had the opportunity (arranged in advance) of talking with a Mennonite minister who had converted from the Amish faith. I felt that he might be able to explain for me the basic difference (or impulsion) that had led him to such a step, and I went to see him with a particular anticipation.

He had been one of many children—eleven brothers and sisters. One of them took an independent turn. He did "a lot of reading, good constructive reading—he was one to be by himself," and he resisted Amish discipline. He led the break, and the other children followed. They felt the Amish were too tradition-bound, not able to give expression to their faith and feelings at the spiritual level (a somewhat

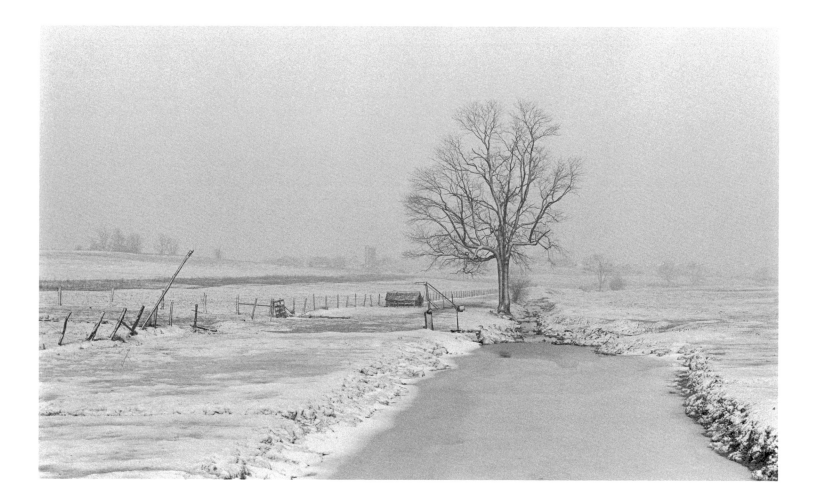

surprising statement). "Our principles are the same, but application and practice differ. The Mennonites take the gospel of Christ with a more positive and aggressive approach in receiving and taking the message to others," and this outgoingness appealed to some basic need. The parents continued Amish but "never exercised *'Meidung'* or shunning as far as we were concerned. And that meant everything to us, that they had that much love for us."

I discussed with him the changes that were occurring. He mentioned that the cities and suburbs were reaching out into farmland "and in a city you can't drop everything and go and help a neighbor. There's a loss of brotherhood. But the Mennonites are trying to overcome that by establishing groups among the poor and the racial minorities. At least we are doing something." The Mennonites have "service units" and integrated churches in the black ghettoes in New York, Chicago, Atlanta, and other cities.

I mentioned the war. He, of course, knew about the Mennonite Voluntary Service in Vietnam. He said, "Few Amish go abroad, almost none. We have volunteers everywhere." He stared at his cluttered living room where children were leaning over a table. "We Mennonites go by a verse in Proverbs that I like to quote: 'When a man's ways please the Lord, he maketh even his enemies to be at peace with him.' We try to make our ways please the Lord."

He meant by that, I'm sure, not just an interior consistency and goodness, but active goodness. I thought of Linny Gehman, who had returned from South Vietnam and after a short restorative visit with his family had volunteered for service in Biafra. Mennonites refuse to yield to the discouragement of the times but carry

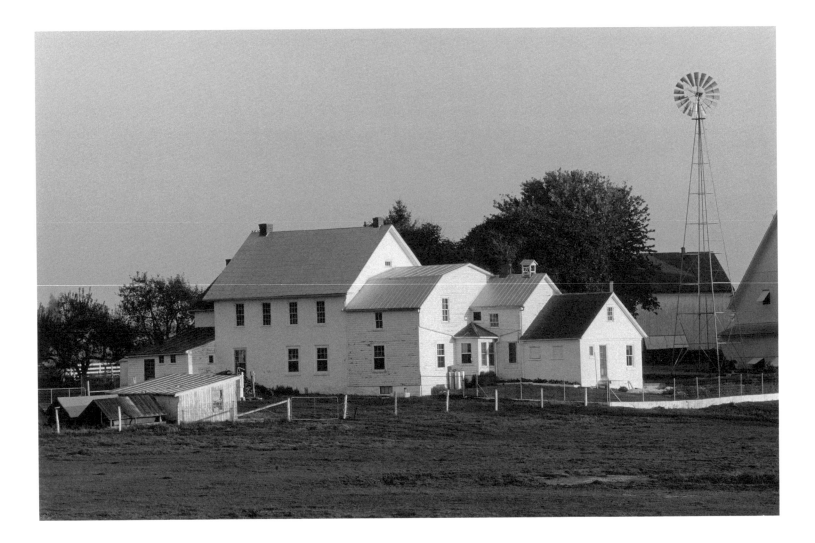

their guitars and their song and their hope, their moral indignation to the danger points of the world.

What the Pennsylvania German plain sects teach is simply that the human species can still want to live by a strong and abiding sense of love. Though for them this love, this brotherhood, is Biblic, one may hope it has elements of universality. With them, with whatever modifications, it seems to endure.

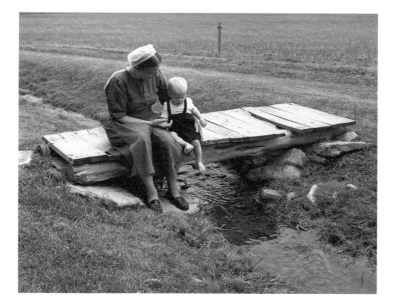

AFTERWORD

WHEN I was twelve, we moved our twenty-five foot house trailer from a trailer camp in New Jersey to another in Lancaster County, Pennsylvania. My mother had recently remarried and persuaded my stepfather, Johnny, to quit his job as a bartender and try her traveling ways. He bought an old Ford truck, mounted a spray painting outfit on the back, and he was in business as a barn painter, like my mother's brothers. Had it been summer, I would have gone out with him searching the countryside for rusted metal roofs to paint as I did for my uncles when I was ten and eleven.

The school year had already started when I was enrolled at East Lampeter Elementary in the autumn of 1950. I had been the "new boy" many times before and I knew that the first day was always stressful. I might be challenged to a fistfight or at least a wrestling match. At East Lampeter it was different; everyone was genuinely friendly and outgoing in a manner that I had not encountered before. The teacher introduced me to my classmates and announced as everyone else knew, that today was the production of their class play, *The Courtship of Miles Standish,* based on Longfellow's poem. The boy who was to play the role of John Alden was out sick–

would I take his place? The teacher would explain to the audience assembled inside the gymnasium that afternoon why I was reading my lines from a book while the other actors had theirs memorized. In one scene as I jumped up and down stomping on eels in the mud, the white crepe paper leggings of my Puritan costume unraveled. I remember most vividly the girl who played Priscilla–and like John Alden I fell in love with her.

Johnny wasn't a salesman. He couldn't convince the Amish and Mennonite farmers that spraying their barn roofs with aluminum paint would cool them in summer and warm them in winter, as my uncles had managed with greater success. After three weeks without a job he came home one November day, paint-speckled and beaming, and threw seventy-five dollars on the table. We had a traditional Thanksgiving dinner and the gloom of insecurity passed for the moment.

Soon thereafter I awoke to the jolting and jarring of the trailer being hitched to the truck. We were moving out; Lancaster was not good territory for a barn painter after all. I would not have a chance to say goodbye to my Pennsylvania sweetheart. Traveling south I considered ways to escape and return, but I didn't, although the longing remained. Our address after that was always General Delivery–places like Fredericksburg, Charlestown, and Jacksonville–but Lancaster left the greatest impression on my mind and heart.

At age twenty-two, I returned to Lancaster a photographer and began the work for this book, which I pursued intermittently over the next nine years. During that time–1960-1969, I earned a living as a home-portrait photographer for a New Jersey studio. My excursions into Pennsylvania were occasional weekend jaunts. Some of these trips were taken with a camera club friend, Richard Bruggemann.

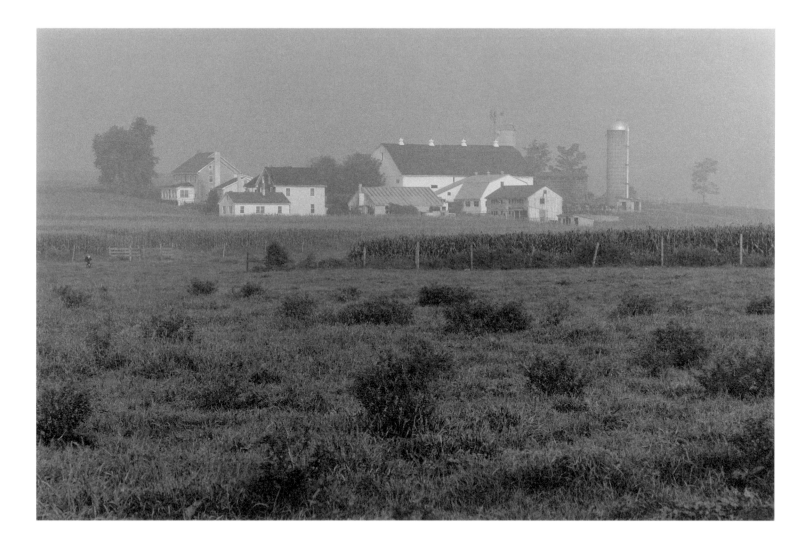

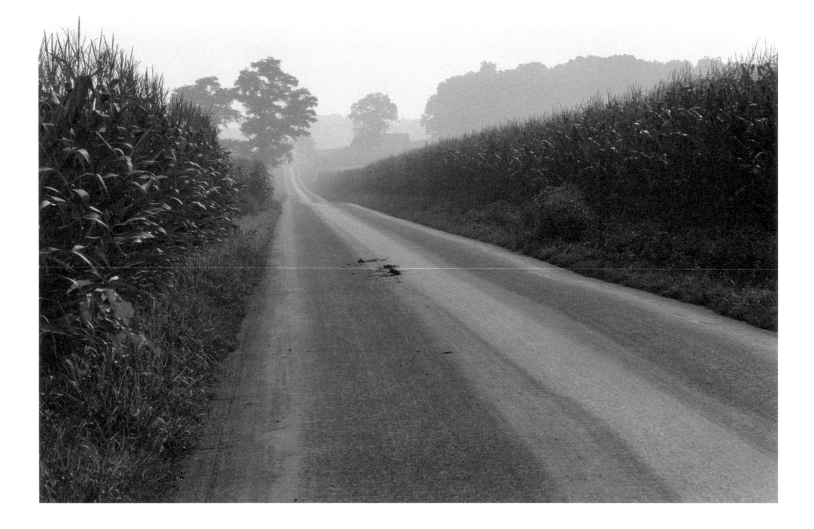

We photographed the same subjects, yet our intentions and results were dissimilar. His were invented. In the darkroom, he could place an Amish horse and buggy inside a Nova Scotia landscape, add a sunset from the Grand Tetons and make it all believable. Of all the many talented members of the Vailsburg Camera Club, he was considered the most accomplished. He learned his techniques from an old pictorialist, Adolf Fassbender, a contemporary of Edward Steichen, known to his students as "Papa." I sometimes wonder what Richard would have thought of today's computer imaging technology.

After a few attempts at Bruggemann's methods of bleaching out the unwanted areas of several negatives and printing them sandwiched together as one, I decided that was not the kind of photography I wanted to do. I wanted my photographs to chronicle truth and beauty as I saw them to suit my aesthetic aims. Richard carried on his photographic forays to Lancaster long after I stopped. He died there when a gust of wind blew his van into an oncoming truck. I miss the long philosophical talks on art and photography while driving home and the sharing of our great expectations for the images we might have taken.

Once, I asked an Amish farmer racing his two mules across the fields like a chariot driver why he was rushing. He answered, "I'm trying to do two days work in one!" That surprised me; I knew the Amish were hard working, but I had thought they labored at their own pace. I was envious of their way of life; peaceful, ordered, idyllic, and so unlike mine.

In the mid-sixties Time-Life assigned me to contrast the Amish with modern society for a book about time for their science series. They used a color photograph I took of a horse-drawn buggy and a speeding car. For *Fields of Peace* I

avoided these twentieth century intrusions entirely. I wanted my photographs to be timeless, like Edward S. Curtis' monumental work on the American Indians.

"A Pennsylvania German Album" is how the book began, an album of fifty bound photographs. The publishing committee at Doubleday & Company said it could not be published without a text. They wanted a Pennsylvania writer—preferably one of their own to write it. I don't recall in which order they were asked before Millen Brand accepted, but Pearl Buck, James Michener, Conrad Richter and John Updike each declined for one reason or another.

In October of 1968, Millen and I made our first and only trip to Lancaster and Berks County together. I was twenty-nine and he was sixty-two. While I looked for subjects to photograph, he was busy interviewing people and taking notes. Millen was a best-selling novelist and award-winning screen-writer, but he considered *Local Lives,* his five hundred page collection of poems about the people he knew in Berks County, to be his most important work.

In August of 1990, I returned once again to Lancaster to see what changes had taken place in the past generation. For three days I drove randomly through Amish and Mennonite country. By chance I came upon many sites I had photographed, and the changes were astonishingly few. Yet, there were some scenes that could not have been mistaken for the 1960's. Now, horse-drawn buggies and all other farm vehicles have large triangular safety reflectors to warn fast approaching motorists. I saw two teenage Amish girls riding ten-speed bicycles. I saw an Amish boy of about twelve on horseback wearing sunglasses and sneakers. I saw young, middle aged, and elderly Amish looking strangely out of uniform in sneakers, too. There were more suburban houses, motels and shopping centers along the high-

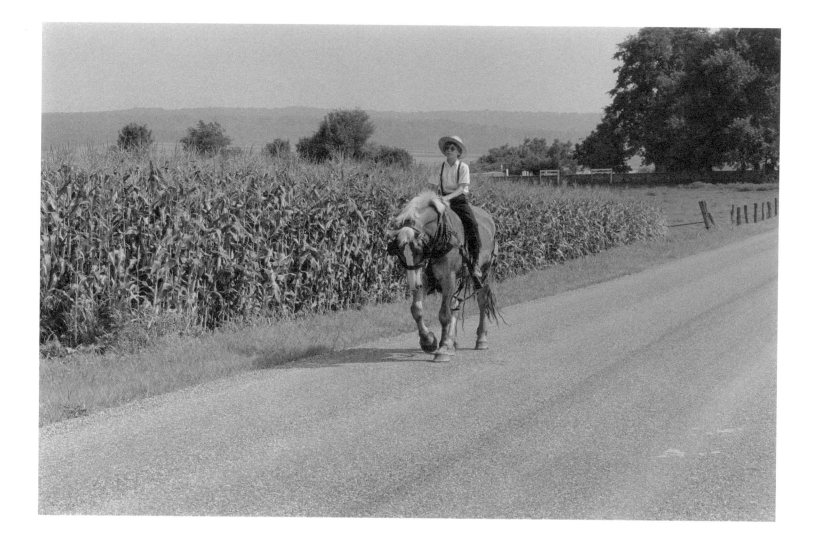

ways, but the back roads—the byways—remained mostly as they had been, mostly fields and pastures reassuring me that the Amish way of life was largely intact.

Although I witnessed no Amish driving cars or trucks, a non-Amish farmer I spoke with pointed out the black pick-up truck he had just bought from his Amish neighbor's son. At age twenty-eight the young man was getting married and joining the church. He would then return to their ancient ways and not drive again. The farmer used an appropriately old-fashioned expression to explain it when he confided to me, "Many of the Amish are marrying later to sow their wild oats."

I came upon a barefoot Amish girl of about nine as she held open a wooden gate for the cows to cross to the barn. Her father, a large man with a kindly face, stood on the opposite side of the roadway coaxing them while my car idled. One calf was reluctant to cross and tried to turn back to pasture, but the girl had already closed the gate and the confused animal didn't know which way to turn. I watched and waited as the Amish man pleaded and implored in the German dialect for several minutes before the calf yielded to his will. The Amish man gave a hearty laugh and embraced the cow affectionately with one arm as he waved me on with the other.

George Tice

Plates

All photographs were taken in Lancaster County except as indicated: (b) Berks County, (m) Mifflin County

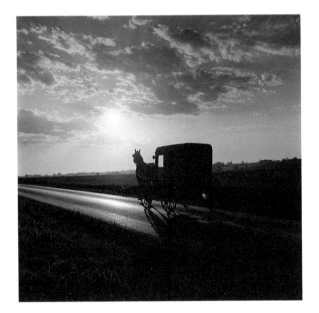

FIELDS OF PEACE

has been set in ITC Bodoni, a modern typeface commissioned and created in this decade and reflecting the designs of the great archtypographer of Parma, Giambattista Bodoni (1740–1813). The design captures the brilliant cutting, the strong contrasts between thicks and thins, and the horizontal stresses that made Bodoni's types (as well as his books) famous throughout late eighteenth-century Europe. Particularly praiseworthy in this modern reissue are the non-lining figures and the small caps, typographic niceties often omitted in digital fonts. The type was supplied through the generous offices of Mark Batty of ITC, New York. ∾ The paper is Caress, a special 100 lb. acid-free sheet made under the supervision of Richard Verney at The Monadnock Paper Mill, Bennington, New Hampshire. ∾ The book was printed at The Stinehour Press in Lunenburg, Vermont, in 300 line screen duotone. Special thanks are due to Bill Glick for his attention to all aspects of the production process. The sheets were bound at The New Hampshire Bindery of Concord, New Hampshire, under the watchful eyes of Tom Ives. ∾ The design and layouts were executed by Earl Tidwell and George Tice.

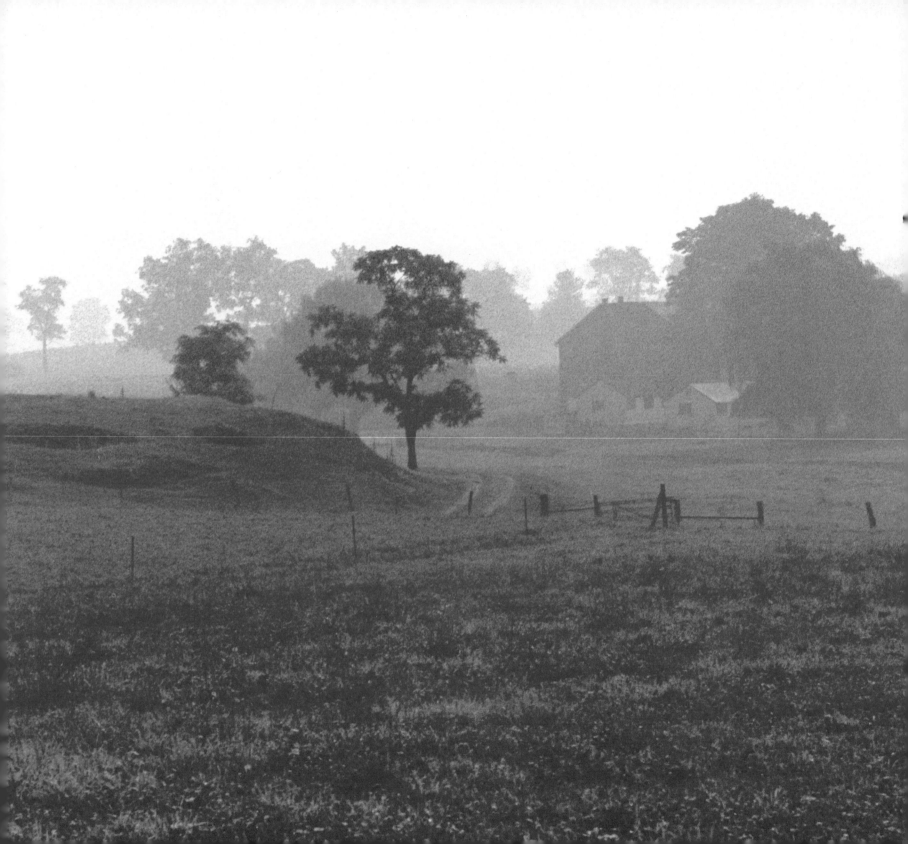